INTRODUCTION

WHY LIGHTROOM?

Lets get straight to the point. You have a massive amount of pictures on your hard drives and are looking for some way to catalog and organize them in addition to doing a large amount of high quality image retouching without having to open each image individually in Photoshop. Adobe Lightroom is the perfect program to do all of these! At first glance it is not the easiest thing to learn though and has many differences between both Bridge and Photoshop. The hotkeys are different, layout is different and many of the functions can be confusing at first. Don't worry though, it gets easier with time and practice.

That is where this guide comes into play. I will take you through the different modules in Lightroom, the workflow process and discuss methods of image retouching at all levels as well as some of the other nifty features that this program has.

What this guide hopes to accomplish is to raise your workflow and retouching skills to the next level no matter if you are amateur or pro. I will take you through an overview of Lightroom and the tools within it in addition to working with a fresh batch of images from several shoots and take you through the whole process from after capturing images to post production and publishing.

WHY THIS BOOK INSTEAD OF OTHERS?

So, with that being said, why should you listen to my advice or read this book? I'm a working editorial and commercial photographer who has been using Lightroom since the first iteration of the software came out. With each passing generation of the software I saw it grow and my skills and talent grew with it to the point they are at today. Lightroom is meant to be used by photographers, both amateur and professional, as a tool to make their workflow process vastly simpler and quicker and that is what I hope to help teach you through this book.

Since most of my assignments are travel related I spend most of my nights in hotel rooms in random countries with only my laptop and Lightroom. Minus a few occasions, all of my workflow is completed using Lightroom. Importing, cataloging, keywording, retouching, publishing and even sending images off to clients all without having to use other programs and software.

Lastly, Lightroom is a program that was designed with the input of photographers and for photographers. It is meant to be used by everyone and not just professional retouchers or designers like some of the other Adobe products are. I, as a photographer, have the benefit of being on both the production and post-production side of my workflow with the use of Lightroom and hope to pass my knowledge on to you.

ADVANTAGES OF LIGHTROOM'S WORKFLOW

With the advent of RAW files and digital cameras, workflow became much more important than before due to the sheer amount of data flowing through. With each file ranging anywhere from 10Mb to 100Mb depending on the type of camera you are using and how fast your shutter finger is clicking away, it eats through hard disk space incredibly fast and the number of files you have created goes higher and higher. Loading folders into programs such as Bridge takes longer than it used to and searching through by date or job is more difficult than before because there are hundreds, if not thousands, of files to sift through.

With Lightroom, you can take advantage of many different features to make the process easier and faster. Catalogs, collections, keywords, metadata, presets, stars and colors are all great tools that will make your life easier after learning how to use them and becoming comfortably using them every day.

LAYOUT OF THIS BOOK

I've written this book in a manner which I find to be logical to both first time users and seasoned Lightroom users alike. It starts out with getting your settings and preferences all set up then dives straight in to getting some images in to your catalog so that you can use them to learn about all of the features and functions of the program instead of explaining everything before letting you use any tools or features. I find that this method works best because it is more about a hands on approach to learning Lightroom and will have a bigger impact when you can try things out yourself instead of simply reading about how to do certain things. All of that aside though, lets get going and jump into the deep end!

CATALOGS

WHAT IS A CATALOG?

Catalogs are base of everything in Lightroom. When first learning about Lightroom I preferred thinking of the catalog files as the great pyramids of Giza – the catalog is the base layer that everything else sits on. You can have one, two or as many as you want depending on your workflow and how you want to organize your images. Just as the pyramids of Giza, each one will be different, but in essence they will all function the same way and be bound by the same rules and regulations.

If you are like most people in the world it will be simpler and easier to just have one massive catalog that contains everything. For some pros out there who shoot millions of images each year, multiple catalogs would be a good idea, but we will tackle that workflow later.

CATALOG CREATION

So, you've installed Lightroom already (if you haven't, go to the Adobe website and follow the instructions there). First thing you will do is create your catalog. By default, Lightroom will create one for you called Lightroom 5 Catalog.lrcat and it will already be there when you open the program for the first time.

If you want to use something else you can either rename the catalog in Explorer or Finder or create a new catalog in a location you specify. To do this, simply click on "File" and "New Catalog."

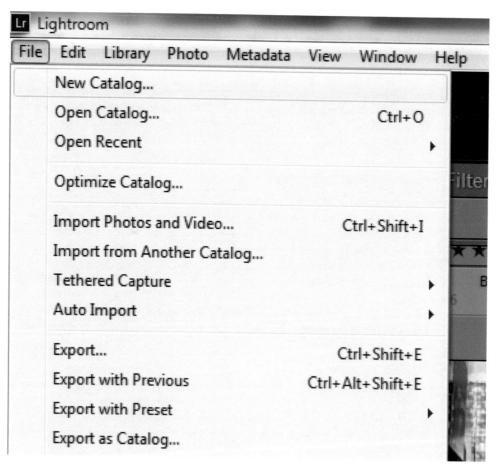

By clicking on that it will bring up this dialog box:

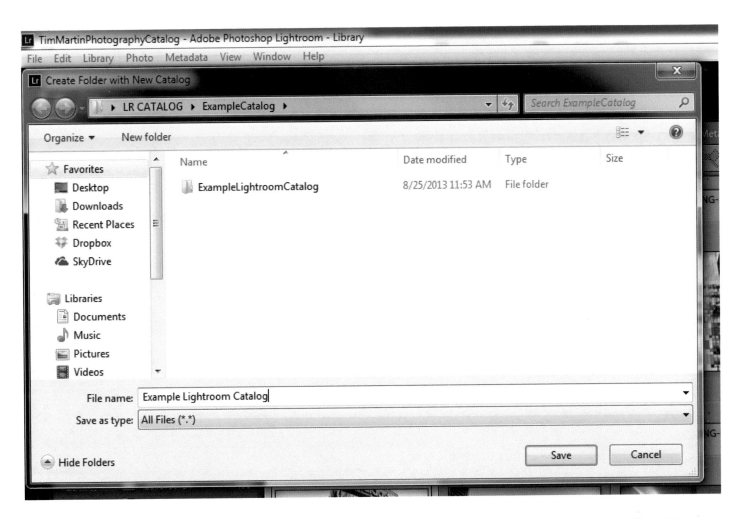

As you can see in the example above, I've made a folder for the new catalog and given it a name. By default the catalog file will be in a hard to remember location, so with mine I always create a folder on the Desktop or any other easily remembered location and store the catalog there. Once you decide the location and name, click 'Save'

CATALOG SETTINGS

Ok, so, you have your catalog. What now? What I like to do before getting too far in is to customize the catalog itself. There are several ways to go about this, and many people are fine with leaving everything to their default settings. If you want to take a look at these settings anyways, it will ultimately improve your workflow process and allow you to customize Lightroom to your liking.

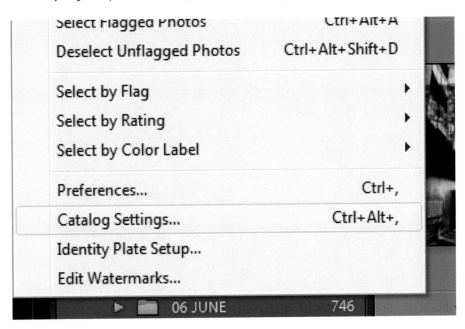

Go to Edit then select Catalog Settings

GENERAL

Click on the tab for "General" within the box that pops up.

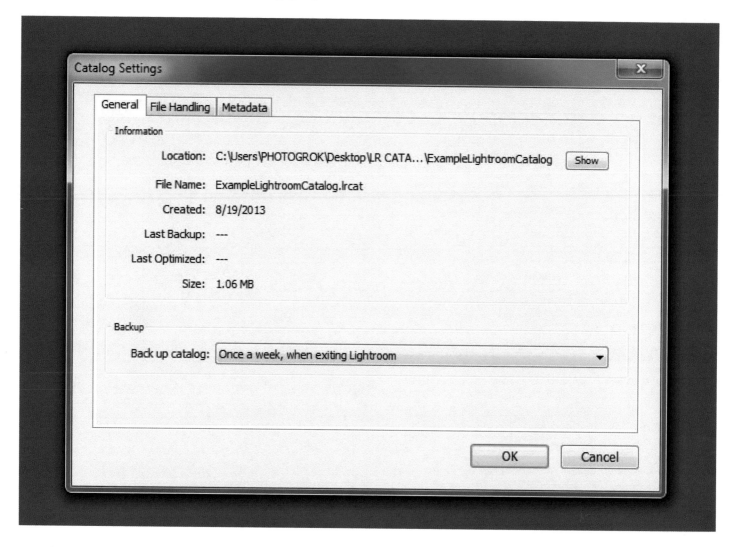

This is where you can set how often you want to backup your catalog folder. Backups take a very short amount of time if there are relatively few images loaded into Lightroom and staggeringly large amounts of time if you have hundreds of thousands of images in a single catalog.

Your choices are: Every time, daily, weekly, monthly, never and the next time you exit Lightroom (single backup only, it will default to whatever it was in before if you use the last option).

I suggest going with the default once a week if you are a casual user who does not depend on Lightroom for work.

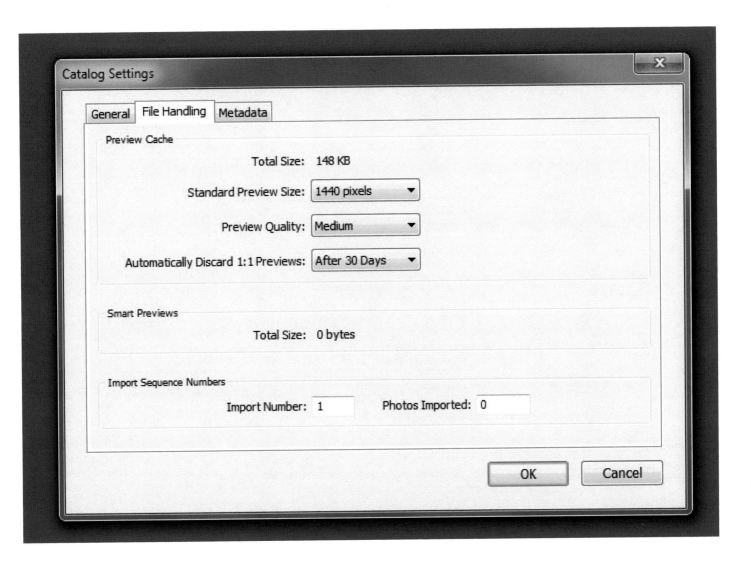

FILE HANDLING

In the "File Handling" tab you can determine the size of the previews and how long to keep them as part of the catalog before they get removed.

The standard preview size is exactly what it sounds like - the size of the preview of the RAW file. Since Lightroom works with ghost files instead of actually opening and closing the file each time you access it, the previews play an important role in determining the speed at which you can view full size images. They also have a big role in determining how large your catalog file will be and how long it will take to import new images as well as backup the catalog files.

For most people the defaults will be just fine, with 1440 pixels at medium quality for the previews. If you are using one of the new MacBook Retina displays though, go for the highest resolution because the default size preview will be very pixelated on your screen.

That thing that says "automatically discard 1:1 previews" will play a big part in the size of your catalog. 1:1 previews are full-resolution previews of the images you have zoomed all the way in to and viewed at 100%. For these images, Lightroom creates new previews that are stored for however long you choose. The benefits of having 1:1 previews are that you won't have to wait for an image to load before being able to apply develop settings on them or viewing them at 100% resolution again. The drawback is the size, which can be of concern to those of us who work on laptops with limited amounts of internal storage.

See that little thing that says "Smart Previews"? That is a new feature in Lightroom 5 which allows you to work on a file with new develop settings without having access to the original file. So if your files are stored on an external hard drive you will still be able to apply new settings without having to plug the hard drive in. Cool, right?

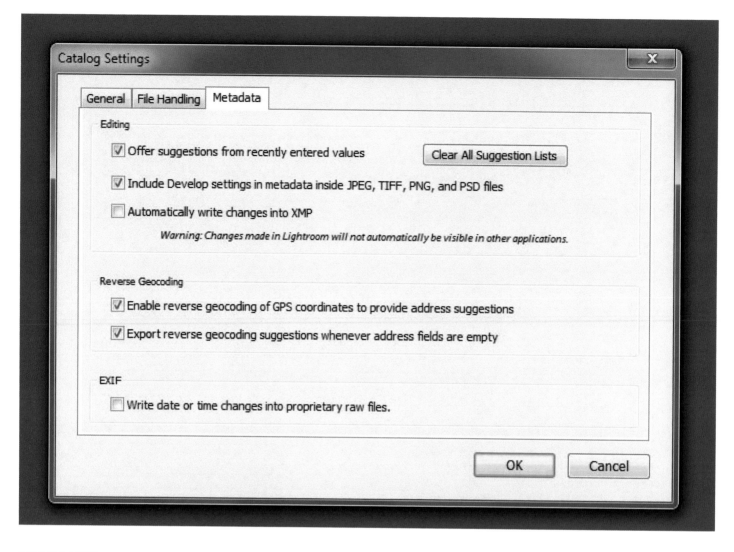

METADATA

Finally, on to the metadata tab. For casual users of Lightroom I wouldn't worry much about this, but for those looking for something a little more advanced, you might want to play around with these settings.

The first checkbox is useful if you are entering IPTC data such as copyright, name and website information into files. Basically if you have this box checked, then any time you enter metadata for an image it will have a little auto-completion thing that shows up if the first letters or numbers entered are the same as one you have entered previously. Also, if you just press the "Tab" key it will auto-fill the metadata box in with the same thing that entered into a corresponding box on the previous file. This is useful for people who do stock photography or want to keyword their images with names, locations and basic data.

The second box is useful if you want to work on any of your images outside of Lightroom. Say, for example, that you do a little bit of re-touching on a file in Lightroom and then want to work on it further in Photoshop but want to be able to adjust some of the settings you applied in Lightroom in Photoshop. A bit confusing, but I hope you understand the gist of it. When working on an image as a "Smart Object" in Photoshop, all of the develop settings will show up and you can tweak them as you want before saving and closing the file in Photoshop or whichever other program you are using. I highly recommend keeping this box checked.

The third box is mostly useful for people who work a lot with metadata and keywording images. XMP files are where metadata is stored. By default, Lightroom does not write changes into XMP files because it is very time consuming. However, if you switch between programs a lot and need to access metadata in all of them, you should check this box. For example, lets say that you keyword an image in Lightroom and want to access the file later on in Bridge. The keywords you applied in Lightroom will only show up in Bridge if they have been written into the XMP file.

Those boxes in the middle: Geo-coding. Its super cool stuff. Leave those where they are and I'll explain further in the section of this book about Maps.

EXIF - I would leave this one alone as well. The only time you would need or want to write date/time changes into the proprietary raw files is if you forgot to set the date/time on your camera and everything is showing up as having been taken on 01 January, 2000.

Any changes that you make to catalog settings will only apply to that specific catalog. If you end up creating additional catalogs, you will need to re-adjust these settings for the new one as well. That aside, lets move on to the preferences for Lightroom next.

PREFERENCES

Unlike the Catalog Settings, preferences span across multiple catalogs and will stay the same even if you switch to a different one. They have more to do with the day-to-day operation of Lightroom and have a much larger effect on appearances.

To access the preferences dialog box simply click Edit then Preferences

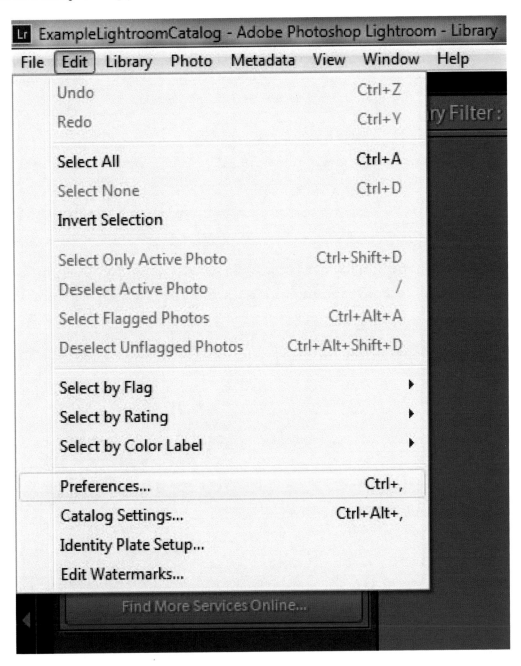

Lets start out with the first tab on the box; General

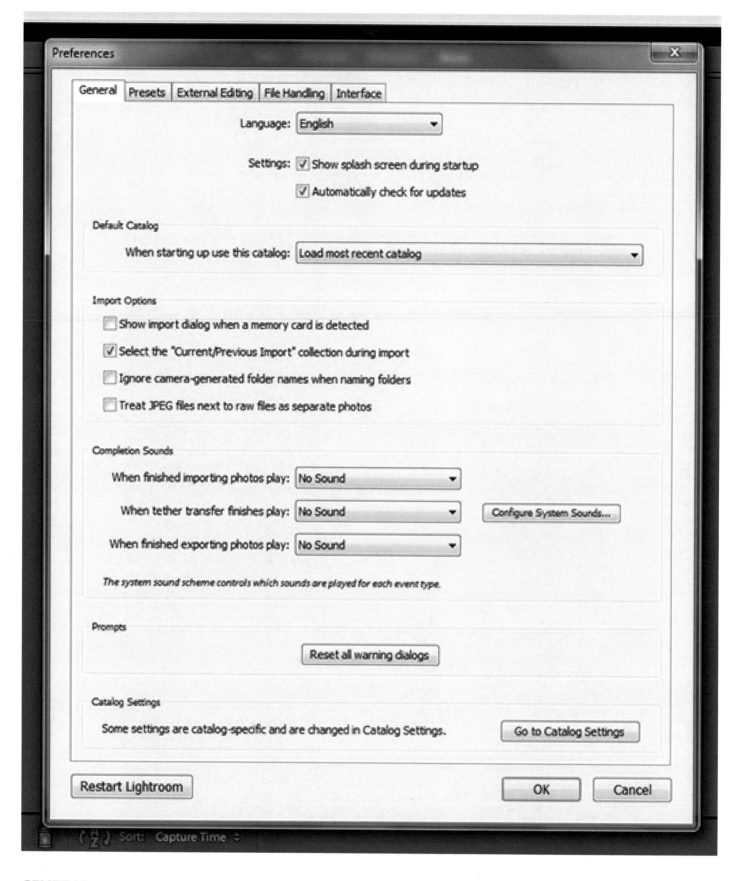

GENERAL

The "General" tab of the preferences is pretty self-explanatory. Language is language, sounds will play or not play depending if you want them to or not. The one section to take notice of here is the "Import Options" section though.

When you plug in your camera via USB cable or put a card into a card reader while Lightroom is open, do you want the import box to pop up automatically? If you want that, then click the first box in the Import Options section. Personally I don't do that because I find pop-ups to be annoying, but a lot of people like having one less button to click when they add new images.

The second option in the import section deals with what Lightroom is showing during import. Do you want to continue working on other images while the new ones are loading in or do you want to watch them as they load into Lightroom? If you want to see the new images coming in, make sure you have a check mark in the box. If not, don't!

If you have a camera that allows you to create folder names while shooting, you may want to check the third box. If your camera is like most of them though, its best to leave this box empty and allow Lightroom to create and name new folders according to what you specify during import.

The last box in the import section, "Treat JPEG files next to raw files as separate photos" is a matter of preference. If you take RAW+-JPEG while shooting, this check box will determine if you see one image or two when viewing the grid in Library mode. If you want to see the JPEG and the RAW separately, as if they were two different images, then put a check mark in this box. If you leave it empty, Lightroom will stack the images on top of each other and add a little "2" to the top right corner of the image, indicating that there are two files instead of just one.

PRESETS

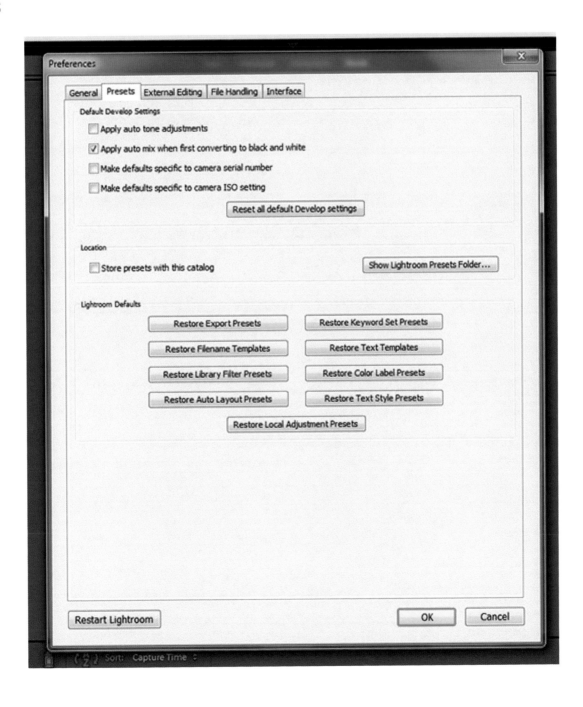

The "Presets" tab in the Preferences box is different from the Presets that we will discuss later in the book. Once you set these, forget about them and ignore the fact that they both have the same name. Anyways, I would leave most of these to the default settings. Since you will most likely want to do more than apply simple auto tone adjustments to an image, I'd recommend leaving the first check box empty.

The second one, which is checked by default, refers to toning of black and white images when you convert them from a color image. With the box checked, Lightroom will automatically adjust the brightness levels of each color channel to mimic what a black and white version should look like. Without the box checked, the conversion from color to black and white will look flat and very bland - you will end up doing more work this way to reach the same final image.

Making defaults specific to camera serial numbers is a very useful thing if you are cataloging images from a wide range of - full size DSLRs, entry level DSLRs, compacts and phones. If this is the case, you can set defaults for each serial number so that pictures from specific cameras will have different default settings than pictures from other cameras.

The fourth box, Make defaults specific to camera ISO setting, can be useful if you are dealing with wide ranges of ISO settings and have very specific defaults for each one. A good example of this would be if you do a lot of noise reduction on images with a very high ISO setting such as 12800 and want to have the noise reduction automatically applied to all images with that setting, but not on images with other ISO settings. Laying on heavy noise reduction to an image with 100ISO would simply reduce the quality for no good reason. For most people I would suggest leaving this box empty.

Storing presets with the catalog can be a tricky thing if you are using more than one catalog. I recommend leaving them in the default location in case you have more than one catalog and want to use the same presets in all of them. Leave this box blank unless you want to have separate presets for separate catalogs and do not wish to swap them around.

If you are ever unsure about where your presets are located, just click on the box that says "Show Lightroom Presets Folder" and it will open Finder or Explorer to the folder where all of them are stored.

EXTERNAL EDITING

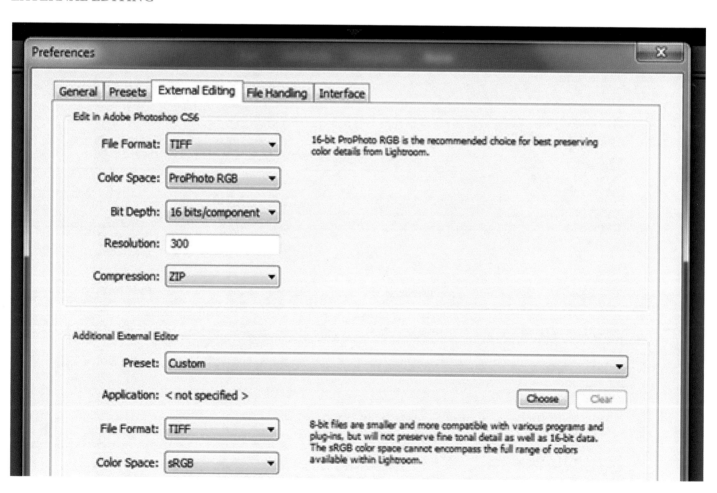

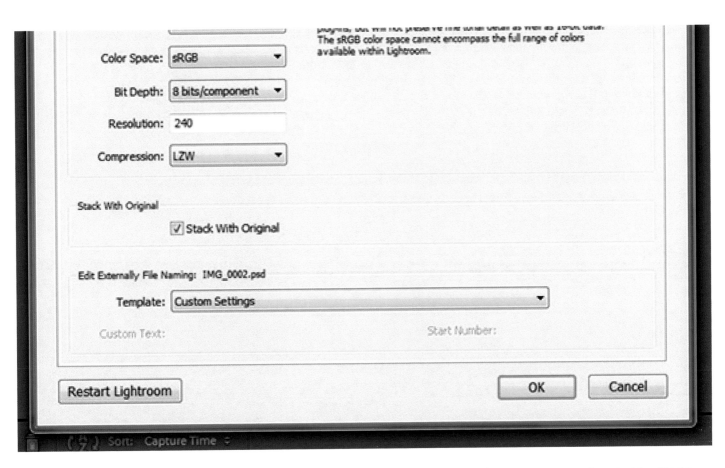

These are the settings that Lightroom will apply when you transfer an image to another application or program from inside of Lightroom.

Depending on the quality you want in the final image you should pay attention to the settings here. When you export an image to Photoshop or another program from within Lightroom these options will not be available for adjustment, so it is important to set them now.

File Format - How much work have you done on the image with adjustment brushes and gradients and other local adjustment tools? If you want to work on the image in Photoshop as a smart object, set this to PSD format so that you can adjust those while in Photoshop. If you do not intend to open images as smart objects and want to just keep the Lightroom adjustments and have a single flattened file, then set it to TIFF. PSD files will be much larger than the TIFF files are.

Color Space - This depends on what the final usage of the image will be. If you are a Pro, I'd suggest using ProPhoto RGB since it keeps more color data than the other two options do. If most of your work is going to appear on the web but not going to be used in print or other mediums than sRGB is best. If you don't plan on viewing the pictures anywhere outside of your own computer or a TV screen then select Adobe RGB)1998).

Bit Depth - One of the more important things in the External Editing panel is this option. Your choices are 8-bit and 16-bit. 8-bit will store less data for colors and pixels than 16-bit will. 16-bit is what you want to use if you will be professionally using these images and plan to do extensive retouching work in Photoshop or another program. If you don't plan on doing much else, then 8-bit will be fine and it also has a much smaller file size.

Resolution - Exactly what it says. Usually you will choose either 72 (optimal web resolution) or 300 (common for printing high-resolution files on photo paper). I'm not really sure why the default in Lightroom is set to 240, so I would suggest changing this to 300dpi.

Compression - These three options will have the biggest effect on how large your file will be (in terms of MB). No compression will give you the biggest file sizes and will keep every part of the file exactly the same when it is saved and re-opened. LZW is what most photographers use because it is lossless (you won't lose any data when opening and closing the file many times) and also has a smaller file size than a file with no compression. ZIP compression is something that most Windows users will be accustomed to. Basically it will use the same compression methods as a standard .zip file would have, but on a single image only instead of a folder of images. While it does give a slightly smaller file size than LZW does, it is not as reliable and the data can corrupt more easily.

Stack with Original - When you are looking at files in the grid view (looks like a contact sheet in Library mode) is the primary place you will notice "stacking" of images. When Lightroom exports an image to another program it will give you choices - edit the original or edit a copy. If you edit a copy of the original with Lightroom adjustments (this is highly recommended by the way) then you will have two thumbnails of the same image file. One with the adjustments before you exported to Photoshop and one with the adjustments created in Photoshop. If you want to "stack" the images so that they are linked together and not treated as separate images, keep this box checked. If you want Lightroom to treat the original and the copy as completely separate files (different creation dates, etc.) then remove the check from this box.

Edit Externally File Naming - Completely up to your own preferences with this. Have any special naming conventions you like to use when working on 12 different versions of the same original file? You can customize the settings in here to do exactly that!

FILE HANDLING

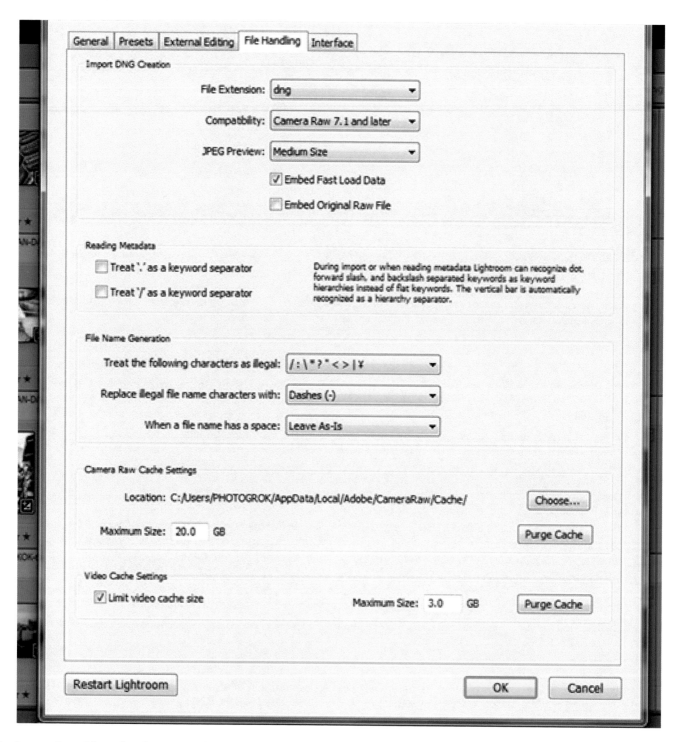

The first section of this tab only matters if you want to use DNG files in your workflow. DNG is a format of RAW file that Adobe has

pledged to support in all successive versions of their software. What that means is when Nikon changes away from .NEF or Canon starts using a different file format than .CR2 and Adobe stops supporting those formats, DNG will still be available and usable.

There is essentially no difference between DNG and your camera's original RAW format aside from the naming structure and the guarantee for file support years from now. That being said, on to the preferences!

File Extension - The two choices are .dng and .DNG and there is no difference between these two. Just a personal preference between upper case and lower case.

Compatibility - Depending on which version of Photoshop you are using you will need to select the correct version of Camera Raw here.. Camera Raw is a part of Photoshop which allows you to manipulate and process RAW files before saving them as a JPG or TIFF file and is much more efficient than using a lossy JPG file.

For Photoshop CS6, use Camera 7.1 and later - this will ensure that all files converted to DNG format will be readable by CS6 and any new version of Photoshop that comes out in the future. If you are unsure which version you need, check with your software and select the relevant Camera Raw version.

JPEG Preview - this will change the size of your DNG file. Previews are useful when viewing the DNG through Explorer (Windows) or Finder (Mac) as well as when using Bridge or any other editing software. Your options for JPEG Preview are None, Medium and Full Size. None will have a smaller file size, Medium a bit larger and Full Size will add a few extra MB of size to your DNG file.

Embed Fast Load Data - By default Lightroom keeps this box checked and I recommend keeping it that way. Fast Load Data is useful in both Lightroom and Bridge. It allows you to load a DNG file faster than it would normally be but also adds on a little extra to the file size. If you're not too concerned about space on your hard drive, keep it checked.

Embed Original Raw File - If you are concerned about losing your original file and want to keep both a .CR2 or .NEF in addition to the newly created DNG, select this box. It will make a very large file in DNG format that contains both the DNG and original formats within the single image file.

Reading Metadata

Lets say that you do a lot of keywording of your images. Doesn't matter if it is for keeping track of family vacation photos and who is in which picture or if it is keywording for stock. If you don't keyword images, ignore this section. If you do, pay attention to these two options.

When importing images into Lightroom you have the option to embed keywords in the files. By default, Lightroom will recognize the ' . ' and ' / ' as flat keyword separators without changing the hierarchy of the keywords (deciding which are more important than others). Automatically, the vertical bar ' | ' separates hierarchy for keywords. So, if you enter your top keywords then want to enter ones at a lower priority, you should put in a ' | ' to denote the separation.

With these preferences though you can use both the dot ' . ' and backslash ' / ' to separate hierarchy instead of simply separating keywords. Check the dot box if you want to use dots, and check the backslash box if you want to use backslash to separate hierarchy.

File Name Generation

Most programs have the same limitations as Lightroom when you want to name files, but here you have the option to change those limitations around. It is not recommended though, so unless you have a very good reason go ahead and skip to the next section.

Treat the following characters as illegal - exactly as it sounds like. The characters selected here will be illegal when naming files. Probably best to not change from the default settings.

Replace illegal character name with - Do you prefer dashes (-), underscores (_), or similar characters (similar to whatever is illegal but is legal). Preference thing here - I use dashes personally because I find them less unpleasant than underscores.

When a file name has a space - Lets say you named your files "Ski Vacation" when importing them. Do you want it to say Ski Vacation.CR2 or Ski-Vacation.CR2? It will have no effect on anything other than appearances but many people prefer to not have spaces within the name of a file. Again, I use dashes here, but you should select whatever you are most accustomed to.

Camera Raw Cache Settings

How many pictures do you have in your catalog? Do you access many pictures from many different shoots all the time or only revisit them in develop mode once in a while? The size of the cache will effect how many files can be accessed instantly in the develop module for editing. While the Previews Cache is used for looking at images in Library Mode, this cache is only used in the Develop Module.

The default size should be fine unless you are working with layered PS files in Lightroom. But, if you want to increase the size of the cache go ahead and do it.

Video Cache Settings - Do you shoot videos and have them in your catalog? If you don't shoot any videos, you should decrease the size of this cache to free up some space on your computer. If you shoot a lot of videos, raise the size of the cache substantially. The cache will effect how much of a video you can watch before it starts to "buffer" and slow down like watching a YouTube video on a slow Internet connection.

INTERFACE

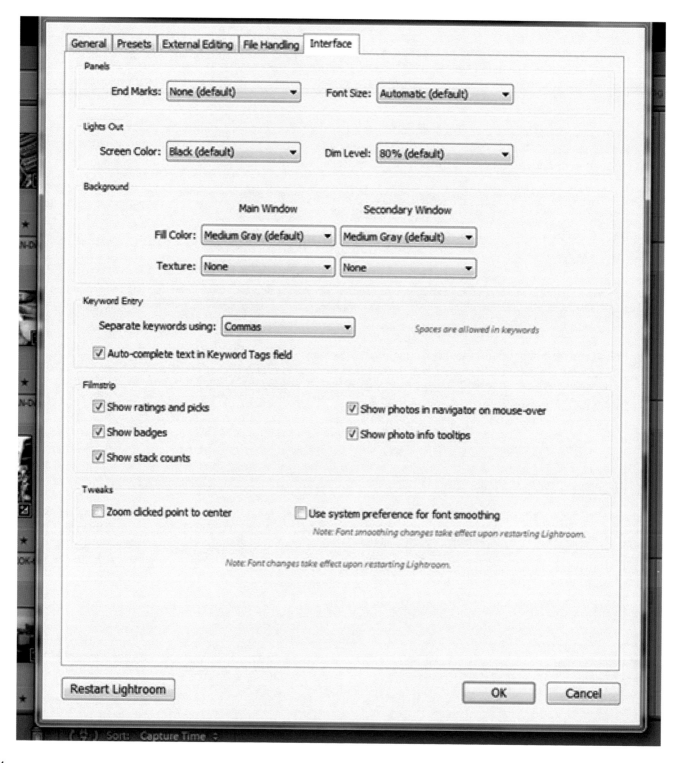

Most of the stuff in this section of the Preferences panel are purely aesthetic and have no effect on the performance or functionality of Lightroom.

End Marks - these are little logos or swirly things that appear on the side panels in Lightroom. You can either design your own and upload them to the end marks folder, use the preloaded one in Lightroom or do what I do and ignore them entirely. Again, they are purely aesthetic.

Font Size - Fairly obvious what this one does. Prefer a bigger font? Set it here!

Lights Out

If you want to see a "cleaner" desktop while working on an image in the Develop or Library mode hit your "L" key on the keyboard. Hitting it once will dim your screen partway for everything except the image and hitting "L" again will make everything on the screen black. Third time is the charm for the "L" key to turn your screen back to normal.

Screen Color - What color do you want to see when you start turning lights out?

Dim Level - When previewing your image with the "lights out" how much do you want to see of the background when it is partially dim? By default Lightroom uses 80% but you should set this to what you feel is most comfortable for your eyes. Everyone has different preferences for this.

Background

Fill Color - Fill color is exactly what it sounds like. Most users like to keep the default where it is since using darker or brighter shades of gray makes it harder to read text or differentiate between the edge of an image and the background.

Texture - Do you want to texture the background fill color? If you do, play with this setting to find something you like. Most photographers find it annoying and distracting from the images and choose "None" here.

Secondary Window - If you use two monitors or like to use multiple windows in Lightroom on the same monitor, play with this setting. If not, ignore it. Most people use the same fill color as their main window.

Keyword Entry

Separate keywords using - Your choices are Commas and Spaces. I'd recommend using commas because sometimes you will need to enter keywords with multiple words.

Auto-complete text in Keyword Tags field - This is a tricky one to choose. If you keyword thousands of images and have hundreds of different keywords, the auto-complete won't work as easily as it would if you only have a few dozen different tags. The reason being is that it will auto-complete the wrong keyword if you don't pay close attention. So, personal choice here. Some people like to have auto-complete enabled and others don't.

Filmstrip

The filmstrip is the area at the bottom of your screen in Library mode. (If it is hidden, click on the little triangle in the center of the bottom of your screen and it will pop up).

Show ratings and picks - Do you want to see the star ratings and flags on these little thumbnails? If yes, check the box. If not, remove the check mark.

Show badges - Badges are little icons to show what things have been applied to an image in Lightroom. There are separate badges for metadata, cropping, develop adjustments, keywords and several other tags. This can be a nifty tool to use if you use larger thumbnails because you can click on a badge and it will open the applicable panel/module for that badge. For example, if you have keyworded an image and want to add new keywords, click on the keyword badge and it will open directly to the keywording panel.

Show stack counts - If you have multiple copies of a single image loaded into Lightroom and have them stacked on top of each other, this will show you how many different versions there are with a simple number.

Show photos in Navigator on mouse-over - If you hover your move over an image in the Filmstrip it will show a larger preview of that

image in the Navigator tab (top right of the screen in Library mode).

Show photo info tooltips - When you hover the mouse over an image in the Filmstrip and keep it there without moving it, a little info box will show up that displays information about the image. The info displayed is the same as the info in Info Overlay in Loupe view.

Tweaks

Zoom clicked point to center - This doesn't really make a difference until you start zooming to the edges of an image. By default Lightroom keeps this box unchecked, which means that if you click to zoom into an image it will center on the point you clicked unless it is at the edge of the photo, in which case it will zoom in but fill the screen with the image and not leave blank space on the sides.

Use system preference for font smoothing - Mac and PC have different ways to smooth fonts and some people get really uptight about the way they want text displayed on their screen. Lightroom has its own font smoothing which is fine for most people, but if you are picky and want to use the same method as your computer uses, click this box.

That is about it for preferences. There are several more that can be changed around, but I'll tackle them when they come up later on in this book. Make sure you click "OK" and restart Lightroom after setting your preferences to make sure they have taken effect.

Now that you have all of your preferences and setting finished, lets get some new images into your catalog!

IMPORTING IMAGES

So you just took a bunch of pictures and want to get them into Lightroom.

Open the program and make sure that you are in the "Library" module. If you look on the top of the screen to the right side you'll see the different module options – Library, Develop, Map, Book, Slideshow, Print and Web. Click on the one that says "Library."

On the bottom left hand of the screen you will see button that says "Import." Click on this. Alternatively, if you have the panel hidden from view (hit the tab key to cycle through the different options to hide panels) then you can click "Ctrl+Shift+I" to open the import dialog box.

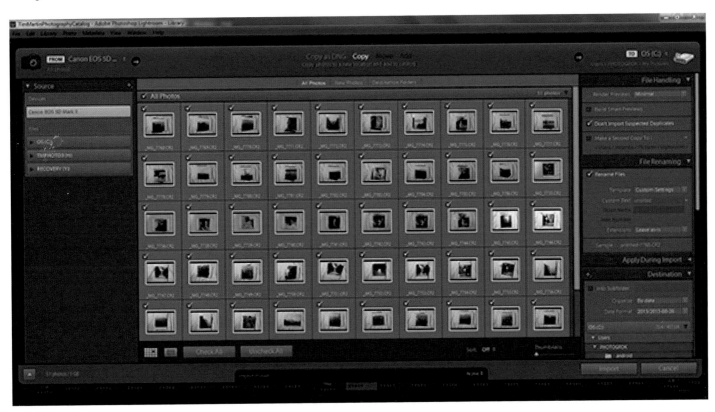

When importing images you will need to select the source of new images. By default if you have a memory card plugged in to your computer or have your camera plugged in via a USB port, those will automatically pop up and display in the grid form that you see here.

If they do not though, look at the upper left side of Lightroom. You will see the spot that says "Source"

Click on the source of new files here. It can be a camera, a memory card, a USB drive or even a folder with images that you already have on your hard drive. Whatever the case might be, select it anyways.

Do you want to import all of the images or just a selection of them?

If you want to import all of the images into your catalog, click the check box that says "All Photos" and it will select everything new. If images have already been imported and are part of the catalog already, it will not include those in the "All Photos" selection.

See the little check marks at the top left corner of each image? If you don't want to include an image, just go ahead and remove the check mark from the images you don't want to include.

Alternatively, if you only have a few pictures you want to add, remove the check mark from "All Photos" select the ones you want individually.

TIP: By selecting multiple images you can batch select or deselect images without clicking so many times. Just Command+Click if you use Mac or Control+Click if you use Windows and select all the images you want to

select or deselect. Once you have all of them, click the check box at the top left corner of any of them and it will apply the selection/deselection to all of the highlighted images!

TIP: Another way to trigger an import of images from files already on your hard drive or plugged in to a card reader is simply to click and drag the files from their source and drop them into Lightroom. To do this you need to be in Library mode though. It will not work if you are in any other module.

Import Type - See that bit at the top center of the screen where it has the words "Copy as DNG" "Copy" "Move" and "Add"? This will decide how Lightroom imports your pictures.

Copy as DNG will copy the new pictures to your hard drive and transform them into DNG format at the same time. If you are going to work in DNG format, it is faster to change them here in the import stage than it is to do it later on.

Copy will keep the same file format that they were in before and copy them to your hard drive.

Add will simply add the new pictures to your Lightroom catalog without changing their location. This only applies for images which are imported from a folder already on your hard drive.

Move will add images to your Lightroom catalog and move them to the location you specify instead of leaving them in the folder they were in before.

For most people, the "Copy" option will be best and the simplest.

IMPORT DESTINATION

Where do you want your pictures to go when you import them? Do you have a lot of pictures and prefer to keep them on a hard drive or do you want to have them on your laptop or desktop?

Most people keep images on their computer instead of an external hard drive because they are not dealing with tens of thousands of images. Professionals usually end up transferring images to a hard drive because of space limitations and it is up to you if you want to transfer to an external hard drive during import or after import.

To select the location you will copy images to, look to the top right side of the screen. You'll see a thing that says "TO" and it will have something selected. By default, Lightroom copies images to the Pictures folder on your internal hard drive and separates them out by date. If you want to keep your files in a different location, I'd suggest doing that here instead of moving them later on just because it saves time and is less of a hassle. Click on the text to the right of "TO" and select the location you want.

IMPORT: FILE HANDLING

Render Previews - How large do you want your previews to be? Previews are what Lightroom uses when viewing images in Library mode. Do you have a big desktop monitor or an iMac or a Retina Display? If so, you will probably want to use the highest resolution for previews here since the small ones will only be useful as thumbnails. If you are using a laptop or smaller screen, the minimal setting is more than okay.

Build Smart Previews - This is a new feature in Lightroom 5 that is really quite cool. Basically a smart preview is a preview file that you can apply adjustments to in the Develop module. Smart previews are much larger and take up vast amounts of space in your catalog. They are very useful for photographers who keep their RAW files on a hard drive and do not want to plug in the hard drive every time they need to work on an image. Smart previews allow you to do this! The import will take much longer than it normally would because Lightroom is creating these smart previews for you.

Don't Import Suspected Duplicates - If you forgot to format your memory card before taking new pictures or if you want to import images from a folder but don't know which ones are already in Lightroom, this is an important box to keep checked. Lightroom will analyze the metadata and size of the file and decide if it has already been imported into your catalog before. I've never seen Lightroom make a mistake with this before, so I think you'll be fine by keeping it with the box checked. If you remove the check mark here then Lightroom will import all images even if it thinks they are duplicates and you will end up with multiple copies of the same file.

Make a Second Copy To - Are you the kind of person who likes to back up your files all the time? This is one way to do it without having to manually transfer files to a second location or use software such as Chronosync. It works the same way as with the first copy to a

specified location and you can select where to create the duplicate copy. Many professionals use this feature because it saves them time down the road.

IMPORT: FILE RENAMING

Want to keep the default file names that your camera creates or use something a bit more personalized? Here is where you can do it.

Click on the box to the right of Template" and select something that looks good to you, or select "Custom Settings" from the template menu and create something that contains exactly what you want.

Personally I always rename my files by a specific project name followed by the original file number. For example, If I took a lot of pictures at Times Square in New York, I would import them using "Times-Square-NYC-2013" in the "Custom Text" box followed by the original file number.

Shoot Name - This is another way you can rename files upon import.

After importing your pictures it is still possible to change the names of your files in Lightroom. If you select all of the pictures you want to rename and then press F2 on your keyboard it will bring up the file renaming option. The other way to reach this option is by selecting all of the pictures you want to rename and then click on Library on the top of your screen and select Rename Photos.

IMPORT: APPLY DURING IMPORT

Develop Settings - Do you have a favorite preset that you want to apply to all of your images while they import? Black and white? Cross process? General tweaks for contrast and saturation? Any of your saved develop presets can be applied here. Be warned though, unless your images are very similar, the preset you select may change some of them a lot more than others. Personally I find it easier to go photo by photo when applying presets in the Develop module.

Metadata - Similar to the Develop Settings, you can apply metadata to every file upon import. I like to do this with my copyright and contact information so that it is embedded in every single file no matter what. You can create and save different presets for metadata and apply them either here during import or later on after selecting your best images.

Keywords - If your images were taken during a family vacation, wouldn't it be nice to apply keywords to them for the most basic information while they are importing? I tend to apply basic keywords during import for things like location, daytime/nighttime, landscapes vs. cityscapes, etc. Just the very basics. When entering keywords be sure to separate them using commas though!

IMPORT: DESTINATION

Where exactly do you want your photos to go on your hard drive (internal or external).

Into Subfolder - This option allows you to create and name a folder for the images you are trying to import. If it is from a fashion shoot, you can title the folder after the fashion shoot name. If it is a holiday to Bermuda, title it Bermuda Holiday Pics. Or just leave this box without a check mark and let Lightroom copy the pictures by year and date within your "Pictures" or "My Pictures" folder as is the default.

Organize - Do you want the images to be organized by the date they were taken on? By the file name? You can select any of the options in here and it will not make any difference in the performance of Lightroom. So, its entirely up to your personal preference.

Date Format - This will depend on what part of the world you are from. People in some countries write their dates differently than people in other countries. Select your preference here.

Below these options you will see the folder structure for the destination you set in the "TO" thing at the top right part of the screen. You can select any folder in here if you want to change away from the default and it will copy images to the folder you specify.

IMPORT: IMPORT PRESETS

At the bottom of your screen you should see a long thin tab with "Import Preset" written on it. You can save all of your import options as a preset and use this instead of re-selecting things every time you need to change them. For example, if you import images both to your internal hard drive and to an external one, but don't want to be bothered by re-selecting the locations every time you switch, you can save a preset for them and just click one button each time.

After all of your settings are set, click the big "Import" button and sit back. Lightroom will start adding your files to the catalog and copying them to the location specified.

AUTO IMPORT

Lightroom has the ability to automatically import images from a specific folder if you prefer to do that instead of adding images manually each time via the normal import dialog. To do this is a fairly simple process but you need to set it up first and here is how to go about doing that!

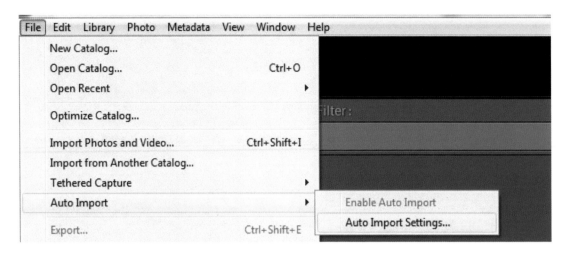

If this is the first time you are setting up an automatic import, go to File and select Auto Import Settings.

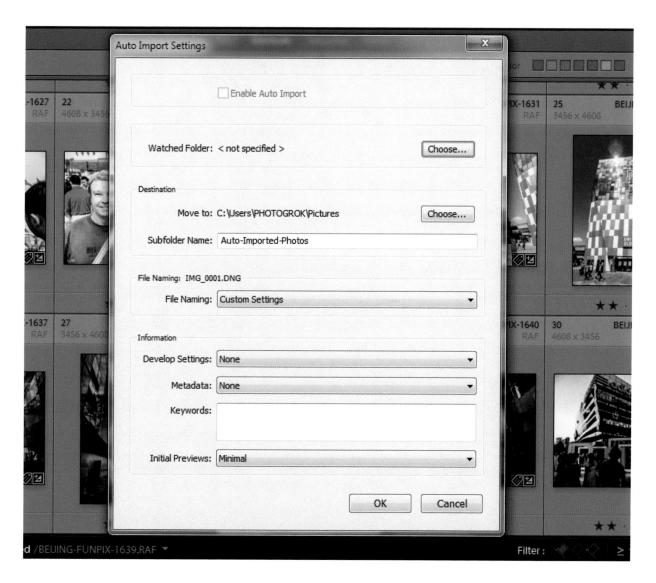

It will bring up this settings box in the screenshot above.

The first thing you will want to do is select a folder for Lightroom to monitor. Basically, anything that gets dumped into this folder will be automatically imported into Lightroom and you will not have to deal with manually importing anything.

Choose a folder where it says Watched Folder. You have to make sure the folder is completely empty though, otherwise Lightroom will not accept that folder and prompt you to select a different one.

Once you have selected a folder make sure that the thing at the top of the settings box has a check mark in it next to Enable Auto-Import.

Destination means the same here as it does in the standard import settings. Where do you want the pictures to go to after they have been imported? Select something here.

Lightroom by default will put them into a folder inside of a folder just for automatically imported images.

File Naming is also the same as it would be with a normal import.

TIP: I would highly recommend using a structured file name if you plan on using auto-import. I say this because if you just use the normal filename that your camera gives the images, Lightroom will develop some problems after 9999 images have been added to the auto-import folder. Most cameras only use four digit numbers along with a prefix like _MG or _IMG and after 9999 pictures you will see multiple files with the same name, but they are actually different pictures. Create a custom file naming preset that uses more than four digits and you will not

Perhaps the easiest way to avoid having multiple files with the same filename is to include the capture or import date with the filename. This will guarantee you will not have any problems!

Develop Settings, Metadata, Keywords and Initial Previews also mean the same here as they do in the standard import, so whatever settings you prefer to use on all of your images I would recommend setting them up here as well.

IMPORT FROM ANOTHER CATALOG

Lets say for the sake of argument that you have multiple catalogs and you want to import images from one of them into another. You can do this, and also keep the develop settings, metadata changes and everything else you've done to that image before!

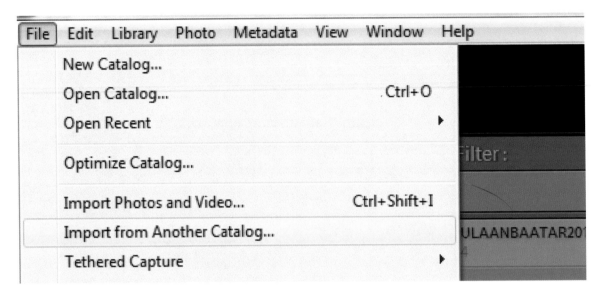

Go to File and select Import from another Catalog. Select the catalog you want to import from and click Open. Please note that it does not need to be from the same version of Lightroom. If you have a Lightroom 4 catalog with images in it that you want to add it won't be a problem at all.

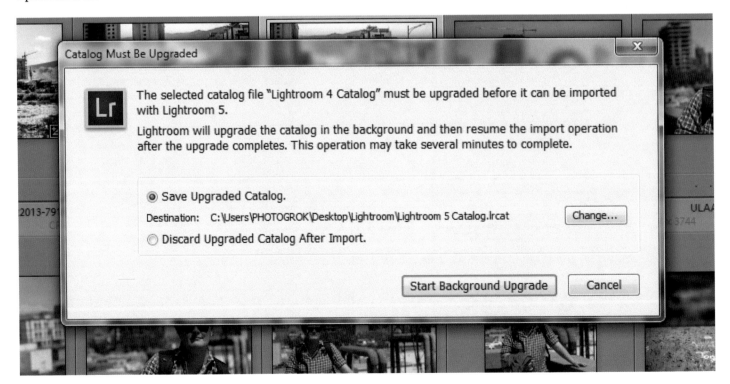

In my example I'm going to import some pictures from a Lightroom 4 catalog. As you can see, Lightroom needs to update the catalog to a Lightroom 5 version before it will be able to import the images. If you are importing from another Lightroom 5 catalog then this dialog box will not show up and you can proceed to the next step.

You can either save or discard the newly created Lightroom 5 catalog after the import and that is entirely up to you. Personally I prefer to save it because it is always better to have the most up to date version of a catalog floating around even if you hardly ever use it.

That being said, go ahead and click Start Background Update. Lightroom will go through all of the images in the other catalog, scan for duplicate files, changes in metadata or develop settings and a range of other things. Once that is all finished it will bring up this box:

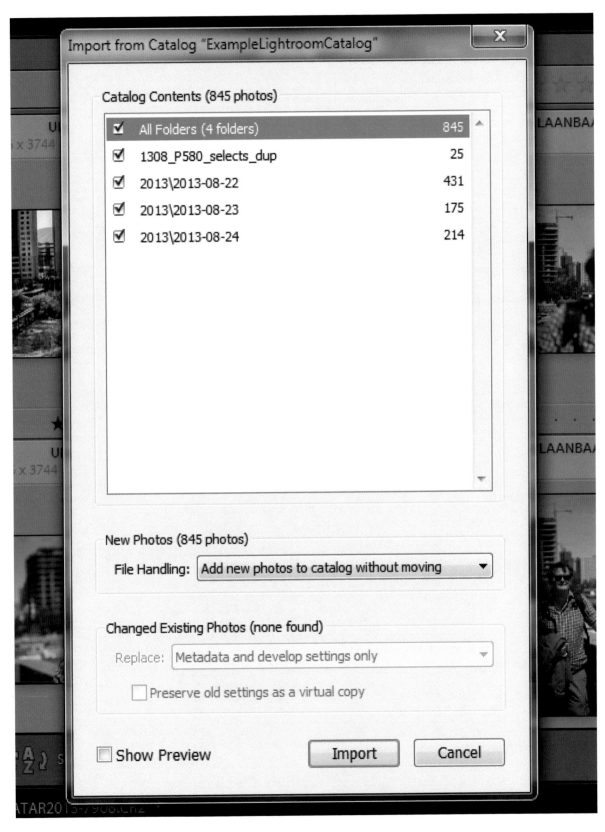

If you want to see previews of the pictures in thumbnail form - similar to the way they appear when you do a normal import, click the checkbox at the bottom that says Show Preview and it will go ahead and do that for you.

File Handling is what it sounds like. Do you want to keep the photos where they are already or want to move them to a different folder and change their filenames? Select an applicable option from this dropdown menu and go from there.

If there are duplicates of pictures but things such as metadata and develop settings have changed, do you want to update those? If you choose the default Metadata and develop settings only option from the dropdown menu, Lightroom will update these settings on the photos currently in your catalog with the new settings from the ones being imported.

Your other options in menu is to not import new photos (if you select this option, you can still update your metadata and develop settings on pictures which have duplicates between the two catalogs).

LIBRARY MODULE

Lightroom is split up into different sections called Modules. You can see these on the top of the screen in big lettering for Library, Develop, Map, Book, Slideshow, Print and Web. To go to Library mode, just click on Library or hit the L key on your keyboard.

This is where you can view all of the images in your catalog and sort them into collections, apply metadata, find specific images and so forth. A lot of people liken the Library module of Lightroom to Bridge. While it does have some similar aspects, it is also very different in the structure and what you can do here.

So, you have a lot of little thumbnails on the screen in the big rectangular section in the middle. These are all previews of your images and you can do all sorts of things to them here.

On the left side of the screen you should see a panel. Lightroom lingo has a lot of quirky words and phrases that Photoshop and Bridge users may not yet be aware of. I'm guessing that most of you reading this book are either unfamiliar with Lightroom's lingo or only know a little bit of it, so please take the time to familiarize yourself with the lingo from the screenshots below.

WHERE THINGS ARE AND WHAT THEY ARE CALLED

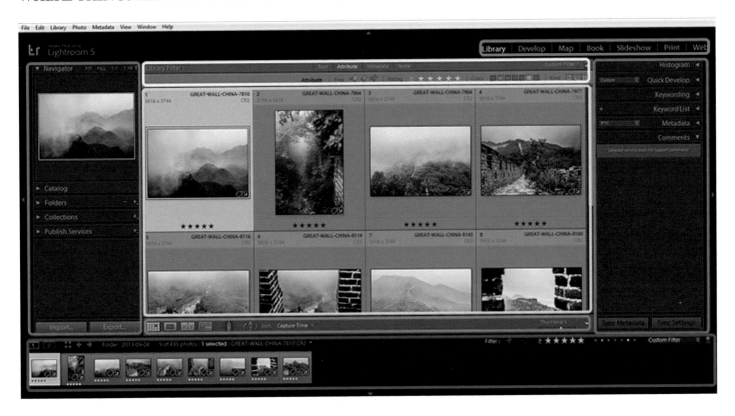

MODULE

Circled in green. Each of the words in here will take you to a different module. Different modules do very different things and there is virtually no overlap in them in terms of what they are capable of doing. Library and Develop are the most commonly used modules.

PANELS

These are the two places which are highlighted in red. You can see them on the left and right sides of the screen and they will be essential in every module that this guide will discuss. I will refer to them as panels from now on.

TABS

Tabs are the things inside each of the panels. You can see that I have collapsed all except one of the panels in this screenshot. Next to each tab you should be able to see a little arrow which, when clicked, will expand the tab to show you all of its contents.

LIBRARY FILTER

The part on the top of the screen which is inside of the white box.

GRID VIEW

The part circled in yellow. It will show a grid of pictures similar to a contact sheet, but with information displayed both above and below each of the thumbnails.

TOOLBAR

The part circled in pink is the toolbar and it is very useful for changing the appearance and functionality of the area directly above it where the grid is currently displayed.

FILMSTRIP

At the bottom of your screen you should see the filmstrip, which looks like a string of thumbnails and will also display some information similar to that on the thumbnails in the grid view. The filmstrip will highlight the image you currently have selected.

LOUPE VIEW

The screenshot above is showing the Loupe view, which is Lightroom lingo for showing a single picture in the center part of the screen. Loupe view and grid view are the two main views you will use for most things in Lightroom and you should familiarize yourself with them. To go to Loupe view, hit the E key on your keyboard. To switch from there to grid view, hit the G key.

Opening and closing sections on the above screenshot is really simple and easy. You can either use the shortcuts which Lightroom has built in already or click on the tiny triangles adjacent to them. If you are unsure of where the arrows are, please refer to the screenshot below.

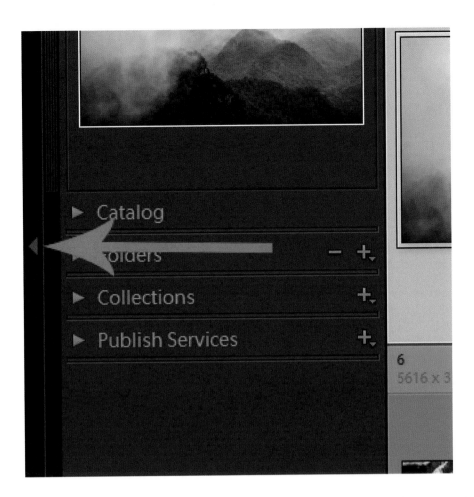

TIP: If you hover your mouse over the little triangles on the edges of your screen when a panel or section is hidden it will pop out and you can use it as you normally would be able to. However, when you move your mouse away the panel will be hidden again. The best way to make sure it is viewable is to click on the triangle or use the tab key to display and hide them.

CUSTOMIZING VIEW OPTIONS

GRID VIEW OPTIONS

Take a look at the grid view on your screen. If you are not there already, just hit G on your keyboard or click on the little icon for grid view. Are you there now? Great! Right+click on any picture in the grid and go all the way down to the thing that says View Options. Click on that.

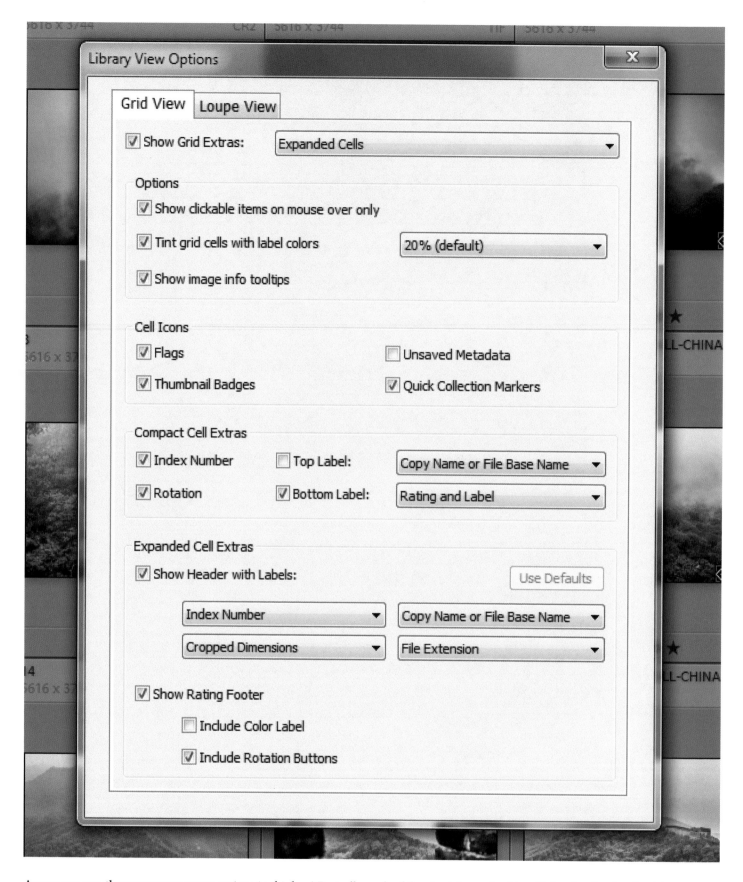

As you can see, there are many many options in this box! Basically, each of the check boxes in this will decide what kinds of things you see when viewing a selection of images in grid view.

Starting up at the top of the options list, you can see that Grid View is selected. We will go over the options for Loupe View right after this, so don't bother checking that tab quite yet.

Show Grid Extras - You have two choices here; Compact cells or expanded cells. A cell is Lightroom lingo for an individual image and the space surrounding it. A compact cell will show only the picture itself and anywhere from 1 to 4 different pieces of information. Expanded cells will show you much more about an image and will be, as the name indicates, expanded! Take a look at each of these choices and decide which one is best for you. Below is a screenshot of what each type of cell looks like.

Options

Show clickable items on mouse over only - clickable items are things like the little circle that pops up on the top right hand corner of an image that will add that image to your target collection or the outline of a flag to give your image a flag status. By default Lightroom has this box checked and I'd recommend keeping it that way because you don't want to accidentally click on them while browsing through a big selection of images.

Tine grid cells with label colors - If you have labeled any of your images with colors, Lightroom will by default tint the whole cell in that color so you can more easily identify it. You can choose to completely do away with this if you want by removing the check mark from this box, or you can click on the menu to the right of it and select how much of a tint you want to have around the image inside the cell.

Your choices are 10, 20, 30, 40 and 50% with 50% being the most colorful of them all. Exit the Grid View options box and label some images with different colors and then go back to the options box and try some of these different tints out to find whatever looks best for you.

Show image info tooltips - When you hover your mouse over an image in the filmstrip at the bottom of your screen, do you want a little box to pop up with information about that picture? The information displayed will be the same as the information in the information overlay you get in Loupe View. If you want this, keep a check mark in the box. If not, make sure the box is empty!

Cell Icons

Flags - Do you want to see if an image has been flagged or not? You can choose to display or hide an image's flag status here. If it is unflagged, nothing will show in either case.

Thumbnail Badges - If you have done keywording or applied develop or metadata changes to an image or cropped it or any number of other things, Lightroom has the ability to create little badges (Lightroom lingo for tiny square icons) that will display at the bottom right side of your images.

See the two badges on this image? The one on the left side means that the image has keywords and the one on the right side means it has develop adjustments. Showing the badges can be a useful way to quickly assess if an image needs additional work or not, but you have to be very detail savvy to do this.

If you don't care about them, then remove the check mark from this box and keep your image looking clean within the thumbnails.

Unsaved Metadata - Do you want to know if metadata on your images hasn't been saved to a file yet? If you keep your images on an external hard drive and mostly work with smart previews or apply metadata changes while your hard drive is not plugged in, I would highly recommend marking this box. This is a very specialized thing and won't effect 98.32% of Lightroom users, so I wouldn't worry about this option if I were you.

Quick Collection Markers - This is the little gray circle that shows up on the top right corner of an image if it is currently in the quick collection. You will see this show up both on the filmstrip and in the grid view if you have this option checked. Personally I find it useful because sometimes I will run through a string of images and second guess myself if I added an image or not, and this is a very easy way to check that without actually clicking on the quick collection.

Compact Cells Extras
Index Number - Do you see a number in light gray numbers to the top left of your pictures in Grid View? That is called the index number. With expanded cells it is always visible, but when compact cells you can choose to not display this if you want.

Rotation - When you hover your mouse over an image do you see two little funky arrows at the bottom left and bottom right of the compact cell? These are rotation arrows and they, as the name indicates, give you the ability to rotate an image, Want to hide them? Take the check mark away from this box. Keep them? Leave it alone!

Top Label - If you click on the box to the right of where it says Top Label you can select anything from it and it will display on top of your image in it's compact cell! Be sure that there is a check mark in the box if you want to see this information though!

Bottom Label - Same thing as with the top label. Click on the box to the right and select anything you want to from here and it will display below the image.

Expanded Cell Extras
Show Header with Labels - See that part at the top of the expanded cells which is a slightly different color of gray compared to the rest of the cell? That is called a header and it is where most of the extra information in an expanded cell is displayed. You can choose to get rid of this if you want to though by removing the check mark from the box.

There are four boxes underneath the check box for this section and you can click on all of them and select whatever you want to have displayed on the top of your cells.

Show Rating Footer - This is that section at the bottom of your image that shows you the number of stars an image has. Want to show it or hide it? I'd highly recommend leaving it how it is with a check mark in the box by default.

Include Color Label - If you check this box you should see a little rectangle pop up to the right of the stars. It will display the color label for your image if it has one and will just appear to be a slightly different shade of gray if it hasn't been labeled with a color. The only time I could see this as being useful is if you disabled tinting the whole cell with a certain color. Other than that, it is just another little thing to add into the already small cell.

Include Rotation buttons - These are the same as the ones in the compact cell. Click the box to keep them displayed and remove the check mark to hide them completely.

LOUPE VIEW OPTIONS

Just as with the Grid View, Loupe view also has some options that can and will effect your workflow process and how you look for certain bits of information about any given image.

To check and set these options just Right+Click on an image while in Loupe View or, if you already had the option box up from Grid View just click on the Loupe tab at the top of it.

Show Info Overlay - The information overlay is the text that you can see at the top left hand corner of your image in Loupe View. Do you like to see that information? If so, keep the box checked and if you think it is annoying, just remove the check mark and be done with it all.

See that box to the right of the check box? It has two options in it; Info 1 and Info 2. Select whichever you want and forget about it because switching between Info 1 and Info 2 is extremely easy without having to open an options menu.

TIP: If you hit the I key on your keyboard while in Loupe View, it will switch between Info 1, Info 2 and None. Try it out for yourself!

Loupe Info 1 - This is where you can select what information will be displayed when you have Info 1 showing on your picture. You can either keep the defaults that Lightroom has (which are pretty standard things you would want to know) or set your own.

That little box that is shaded out at the bottom of the three choices can only be clicked if you are not displaying information on your images. So, if you put a check mark in the box to show information overlays just ignore this shaded out one.

Loupe Info 2 - Same as the first one. Select what you want to see and move on.

General
Show message when rendering or loading photos - This is pretty straightforward. Do you want Lightroom to tell you it is loading an image, or not. I'd recommend leaving this box checked because without it you may keep waiting on an image to load when in reality it is simply not in focus.

Show frame number when displaying video time - Also a very straightforward option here. If you regularly shoot video you will already know what this means. If not, then I wouldn't worry too much about it. Just keep this box checked.

Play HD video at draft quality - Does your computer have some pretty powerful things inside of it that are able to play source files for HD video without buffering or rendering too much? If that is the case, you can remove the check mark from here, but be warned that your cache will probably fill up quickly.

If you are like most users though, I'd highly recommend keeping this thing selected. Basically, draft quality is a quality less than full HD and will take less time to load and view. It will look the same for most people unless you are using one of those fancy new Retina displays from Apple or a really swanky monitor for a desktop from any number of brands.

LEFT PANEL

Take a look at the left side of your screen to the panel with the five different tabs: Navigator, Catalog, Folders, Collections and Publish Services. Some of these tabs, such as the Navigator, are the same in different modules, but all of the others are specific to the Library Module and can only be accessed through here. Let me explain a bit about what each one does and how to use them.

NAVIGATOR TAB

Think of this as a miniature preview. By default the Navigator is set to a view which will fit the entire image into the main image viewing area where the thumbnail contact sheet/large image preview are, meaning it will display a small version of it without cropping anything out. There are other views available though which can be useful when checking for things like critical focus and sharpness. Do you see those options above the preview? They should say FIT, FILL, 1:1, and then something else with a couple of triangles pointing up and down next to it.

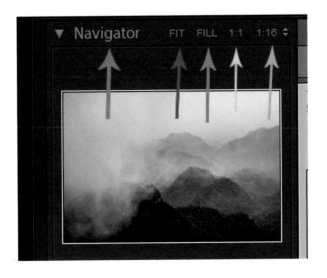

Fit (blue arrow) is exactly what I described above, where it will make the entire image fit in the *Loupe* view without hiding any parts of the image from view.

Fill (green arrow) will take the image and put as much of it into the Loupe view as possible but will also hide some of it. The benefit of using this view is that you will be able to see more detail in most of the image because there will not be any empty space in the Loupe. Of course the downfall is that you will not be able to see some parts of the image unless you manually move the focal box on the Navigator to view those parts.

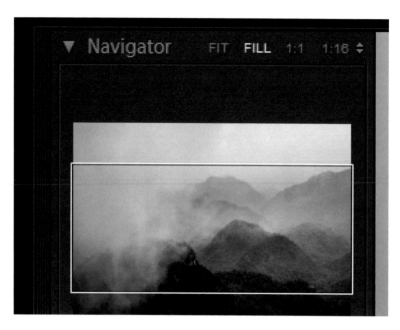

1:1 (yellow arrow) Is a 100% view of your image in the Loupe. One pixel on your screen will be equal to one pixel in the image. This is the best way to check for focus and sharpness on your images because you will be able to see it in very fine and up close detail.

The other options to the right of 1:1 (beige arrow) are for different levels of zoom. The number on the left denotes the number of pixels on your screen and the number on the right denotes the number of pixels that it represents in your picture. To clear up that language a little bit, lets go through a couple examples.

If the ratio is set at 1:4 it means that the image you are viewing in the Loupe has one pixel showing for every four pixels in the full size image.

If the ratio is set to 8:1 then there will be 8 pixels on the screen for every pixel in the image, which would mean you are viewing an image at eight times the resolution it was shot at.

Make sense? I wouldn't worry too much about this. All you really need to know is the difference between FIT, FILL and 1:1 because those are the most useful ones.

Right, so lets say you are viewing images with the FILL option. Do you want to see the parts of your image which are being hidden from view? If you look at the Navigator you should see a white rectangle in the little preview image. The area inside of this rectangle is what is currently being shown in the Loupe. To move it around, just click your mouse outside of the white rectangle that you want to see. The rectangle will move and you should see these changes being reflected in the Loupe.

If you are viewing at the 1:1 view you can do the same thing to move around your image. Just click on the spot you want to view in the Loupe and the box will move around to that spot and show it to you in the Loupe.

CATALOG TAB

This section is fairly simple and only has a few things inside of it. It is where you can see the numbers of images in different states.

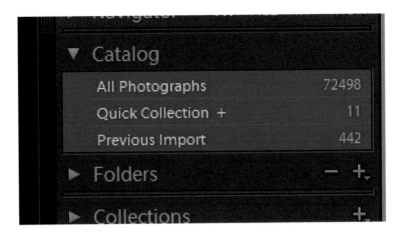

All Photographs - This is simple enough. It will show you all of your photographs in the current catalog.

Quick collection - This is a place where you can collect images without having to create anything to hold them in. A collection is like a virtual folder on your desktop. It doesn't really exist, but in Lightroom you can place images here when you need to. For example, lets say that you are sorting through a bunch of new images and see some that you really really like and want to apply some Develop settings to, but don't want to add star ratings or flags to them yet. Easy enough, just hit the B key on your keyboard and it will add the image to this Quick Collection. Click on Quick Collection to view all of the images that are currently in here.

To remove an image from the Quick Collection just press B again and it will be gone.

There are a couple of ways to add images to your Quick collection. One is, as mentioned above, to hit the B key. Another is to click and drag the image from the grid view or filmstrip into the Quick Collection.

NOTE: If you set your target collection to something other than Quick Collection, the B key shortcut will not add images to the Quick Collection.

Previous Import - This will show you all of the images from your most recent import.

FOLDERS TAB

Where all of your files are at according to Lightroom. If you have imported images only to your internal hard drive then this should be a very simple and easy thing to sort through, If you split images across multiple hard drives and other devices it will be a little more complicated. Either way, the folder structure here represents where Lightroom last accessed your images from.

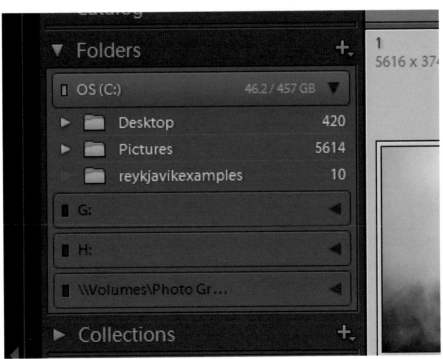

As you can see in the screenshot, I have images stored on four separate drives. The first one, OS(C:) is the internal hard drive of my computer. Inside of there you can see the folder structure and the locations of all of the images which have been added to Lightroom from that specific hard drive.

The ones below it are G:, H: and a volume drive. Do you see how the text for those ones is black? That means that these drives are not currently plugged in to the computer and are "offline" Since they are offline, Lightroom has a very limited ability to work with the files stored on these hard drives unless you have generated smart previews for them.

It is worth noting that if you move a folder or rename a folder with images in it, Lightroom will not automatically be able to find them again. You will need to manually re-link the folders in this section.

So, how exactly do you go about re-linking folders which have been moved or changed names or are unlinked for any other reason?

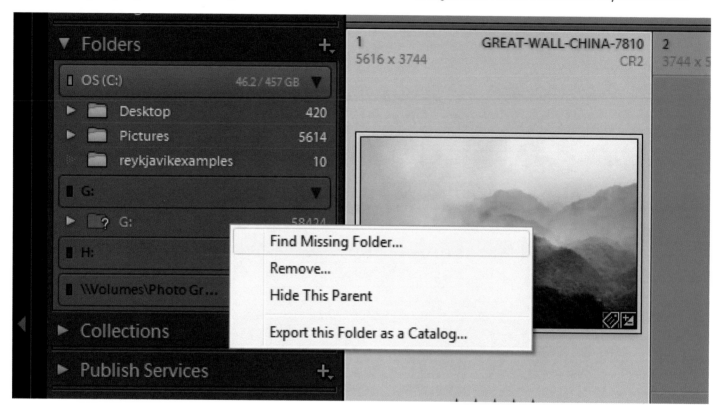

Do you see where the question marks are next to some of the folders in the screenshot? The question mark denotes that Lightroom can't find the files. This could be because the name or location has changed or because I do not have that specific hard drive plugged in.

In order to re-link the folder so that you can access your images and apply develop settings to them or export and publish them, you will need to right click (control + click for Mac users) on the folder in question. A little menu should pop up and the top option will be Find Missing Folder. Click this.

A window will pop up and you will need to find and select the correct folder location then click Select Folder. After this is done, Lightroom will re-link the images in that folder and update the location within the folder structure list here.

COLLECTIONS TAB

One of the most powerful organizational tools in Lightroom is collections. These are like virtual folders that Lightroom uses to organize images in whichever way you want it to. You can organize collections into Collection Sets.

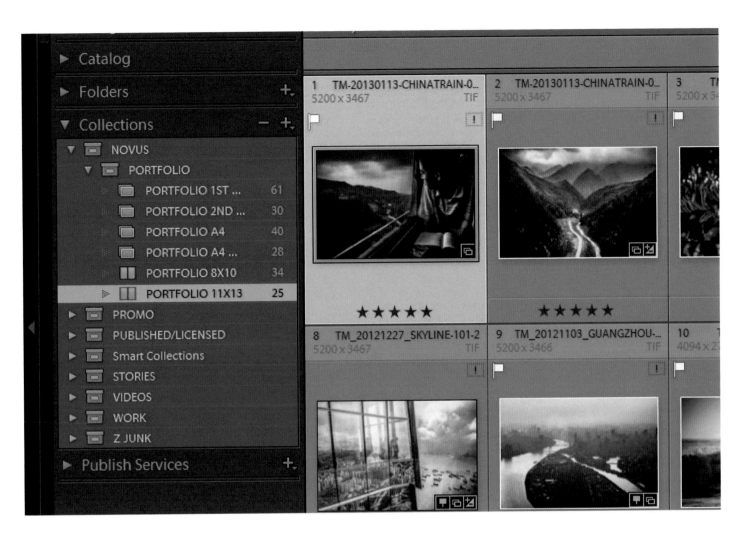

There are three types of collections; Collection Sets, Smart Collections and Collections. Smart collections are, as their name indicates, smart. They have pre set controls that will allow photos to automatically be ingested into them. A standard collection is one which does not have any smart elements to it and you just drag and drop images into it and a collection set contains groups of collections and smart collections.

How do you create a collection? Simple enough. You see the little plus sign to the right of where it says Collections? Click on that. It will bring up a little thing that has a few options on it. Create Collection, Create Smart Collection and Create Collection Set.

TIP: You can sort collections by their type or alphabetically. If you sort by type, all of your Collection Sets will be grouped together in alphabetical order followed by Smart Collections in Alphabetic order followed by Collections in alphabetic order. If you want to do away with this and just have them sorted alphabetically as a whole without grouping by type, click the plus sign next to Collections and put a check mark next to Sort by Name.

Collection Set
These are easiest to think of as collections for collections. You can add smart collections and normal collections to them, but nothing else. Kind of like folders on your desktop, but they can't directly contain images. Check out the screenshot to see the structure of collections and collection sets. As you can see, the collection sets are the top tier and inside of those I have standard collections and several books.

The icon for a collection set will look like a box with a little light gray colored rectangle inside of it.

Collection - These are the easiest ones to create and use. They act a lot like a folder on your desktop where you can drag and drop things into and out of at will.

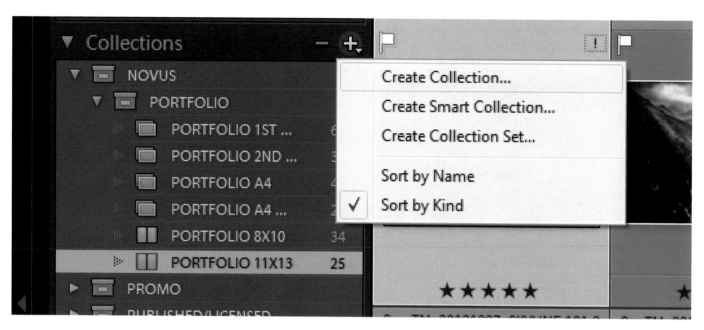

Creating a Collection

See that little plus symbol on the right side of the tab? Click on that and select Create Collection. It will prompt you for a name in the box that opens up and you should go ahead and put whatever you want in there.

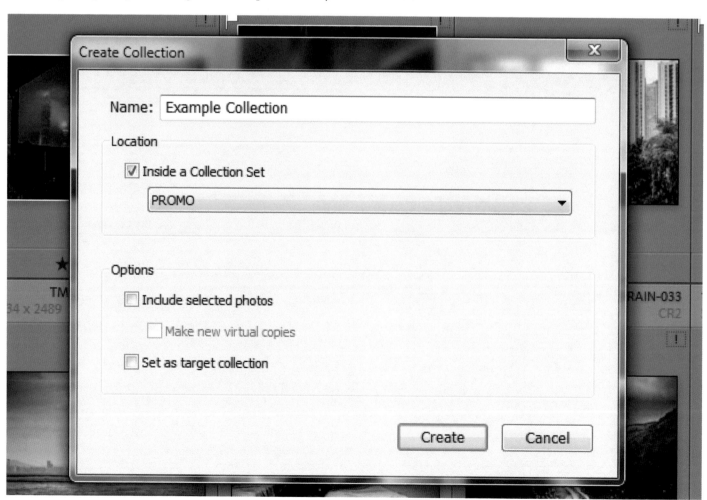

Below that is Location. If you already have Collection Sets, select which one you want to put it into. If not, just leave the box unchecked and the new Collection will just be placed under the Collections tab wherever it falls alphabetically.

If you already selected a bunch of images and are creating the collection after selecting them, you will want to put a check mark in the box for Include selected photos. Once you select this box, the one below it will open up and you have the option to make new virtual copies. If you are not sure what those are, please refer to the section on virtual copies.

If you don't care about putting it inside a collection set or have not set any up yet then just remove the check mark from that box and it will be set adjacent to any other collections you have created.

The last check box here is to set this new collection as the target collection. What this means is that when you press the B key, pictures will be put into this collection instead of into the quick collection. Personally I find this to be useful, but at the same time I'll forget what the target collection is set as and will accidentally add images to it when I wanted to add them to the quick collection. So, it is completely up to a personal preference.

If you plan on looking through a large amount of images and want to add a lot of them to this new collection it will be easier to do that using a shortcut than it would be by dragging them individually into it.

TIP: Once you have created a collection, you can simply drag and drop it into a collection set. To do this, just open the collections tab and drag and drop the one you want to move into any collection set you have created. It will not change anything inside the collection and will merely move the location of it. You cannot place this inside a standard collection or a smart collection.

Smart Collection

Just as with a standard collection, create a name for the smart collection.

Below that you can check the box if you have already created a collection set and place it inside of it if you want to.

Now do you see where it says Rating? Check the screenshot for a reference if you can't find it. This is the default that comes up when you create a new smart collection. Click on the box that says Rating and select any applicable field that you want to use. If you want your smart collection to contain all of the images taken with a specific camera, then go select Camera Info and then Camera. If you want your smart collection to collect images that were taken in a specific country, then select Location and then Country. There are tons of options in this and you can create smart collections for any number of things.

After you select the applicable field that you want the collection to add images for click on the next box to the right. It will have a list of options inside of it that should be very self-explanatory. Select whichever one you want and then enter text into the box to the right of that. It will make much more sense if you go ahead and try it out on your computer since the number of options available would take up quite a few pages of text in this guide.

Last thing to go over here is the criteria for what matches. Do you see that box that says all? Click on it. Your options are all, any and none. This will apply to all of the things listed below it. So, if you want the smart collection to add images which meet all of the things you selected, then choose all. If you want it to add images which meet only one, but not necessarily all of them, then select any. And, if you want it to add images which meet none of the criteria then select none.

If you want to use more than one criteria in your smart collections, click the plus symbol at the far right of any of the criteria you have already set. This will add another field for you to set up. Still want more? Just keep clicking that plus symbol to keep adding more and more!

I use smart collections for all and none. Each of them serves a very distinct purpose and I use them very often. The power of them being smart collections is that you don't have to manually manage them and they will do all of the work for you once they have been set up.

Check out the next screenshot for a smart collection I have created. It will automatically add all images that were taken in China and have a 5-star rating and captured using a Canon 5D Mark II.

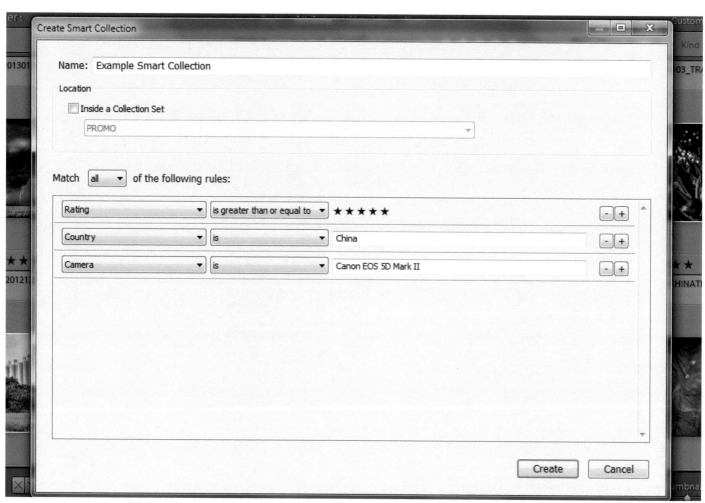

I use this model to gather images together from all of the countries I have taken pictures in. Whenever I import new images, I always add location data for the city and country they were taken in. Camera information is always there in the metadata, so I don't need to add any of that myself. And the 5-star ratings are what I use to denote the best images from the shoot. So, when I click on this smart collection for China images it will show me the best pictures from there which were taken with my good camera instead of a phone or point and shoot (snapshots with friends and family kind of stuff).

The next screenshot is a smart collection I set up for images created in China that have been rated between 2 and 4 stars and have been taken with the Canon 5D Mark II. These are images which I sorted through but didn't think were good enough to make the cut to the top 5-star rating.

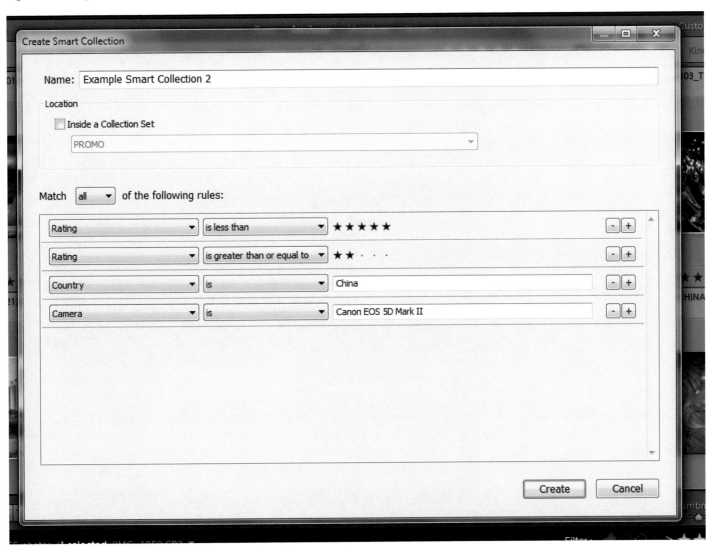

And, the last smart collection I am going to share with you is one that I use all the time. It is for images with no ratings, no develop adjustments, no flags and no presets. Basically, images which have been imported and then left to collect digital dust on my hard drives. Periodically I will look through these and delete some from my hard drives. Images that are taking up valuable space and that I know I will never, ever, need or want to use them.

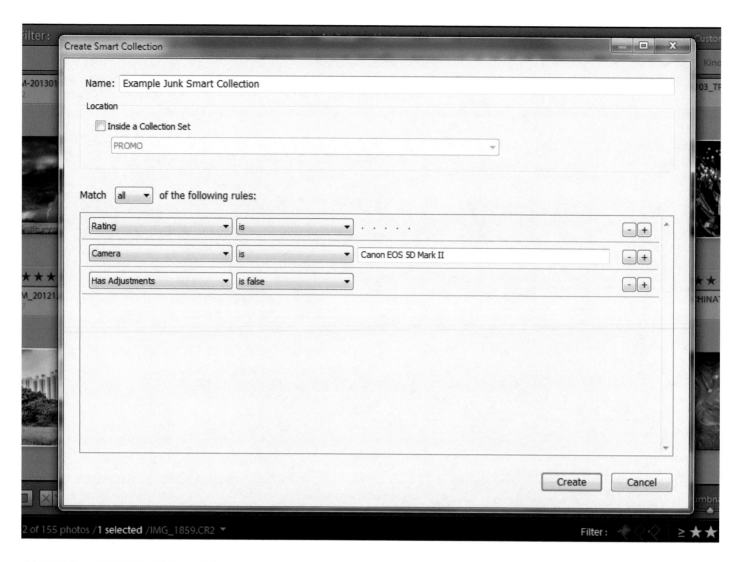

SAVING A QUICK COLLECTION

Just for the heck of it, lets say that you added a bunch of images to the quick collection for whatever reason you might have had and you want to save those as a new collection. Normally, you would have to go through the process of clicking the plus symbol and creating a new collection, transferring images to it and yada yada yada. There is an easier way to do that though if your images are all in the quick collection!

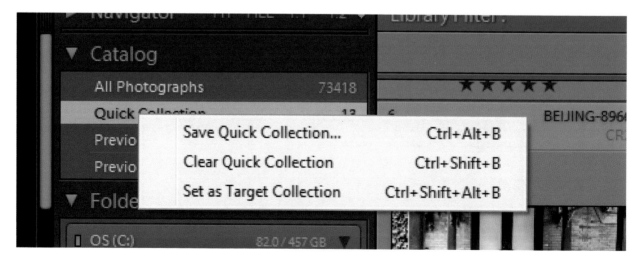

If you right click on the quick collection or go to File and select Save Quick collection it will bring up a new box that looks like this:

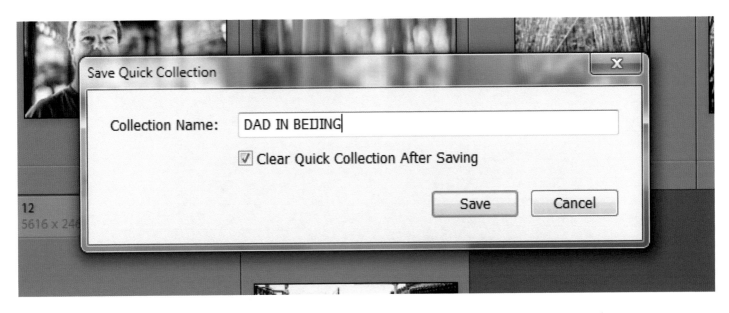

Just give your quick collection a name and it will be created with that name in the top tier of the collections tab.

Do you want to remove all of those pictures from the quick collection after making a new one with those pictures? Put a check mark in the box!

TIP: When saving a quick collection you do not have the option to place it within an existing collection set. To do that you will need to click and drag it from where it is into the desired collection set within the Collections tab on the left panel.

PUBLISH SERVICES TAB

Do you have a Flickr or Facebook account that you are always putting images on? With Lightroom's publishing services it is easier than ever to add more and more images to them without having to go through the web!

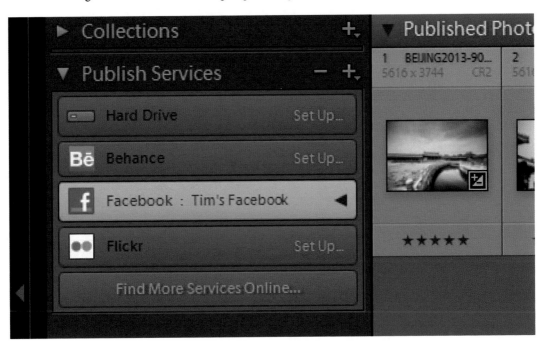

By default Lightroom has Behance, Facebook and Flickr already installed as options here in addition to your hard drive. There are many others available as well if you search the web and find plugins for them. For example, there is a Tumblr plugin that you can install to Lightroom that will let you publish directly there as well. If you want to add new publishing services then click the plus symbol to the right of Publishing Services and go to the top of the list and select Publishing Manager. From there go to Plug-in Manager down at the bottom of the left side. It will bring up another screen and from there you should click on Add, which is at the bottom left side as well.

If you are installing plug-ins for additional services I recommend following the instructions on the website for whichever plug-in you are adding. They will have very detailed instructions for installation and setup and each one will be a little different when it comes to accounts and usernames and passwords and whatnot.

Lets just go ahead and set up one for Facebook though since that is already here. Exit out of all of those menu boxes and just look at the main screen in Library mode for Lightroom. Where it says Facebook, click Set Up, which appears to the right of Facebook.

It will bring up a box for you to fill in all of the information needed.

Publish Service - Under Description you can either leave it blank or add a name for it. In my example, I'll write Tim's Facebook so that I know it is my Facebook account it is logging in to.

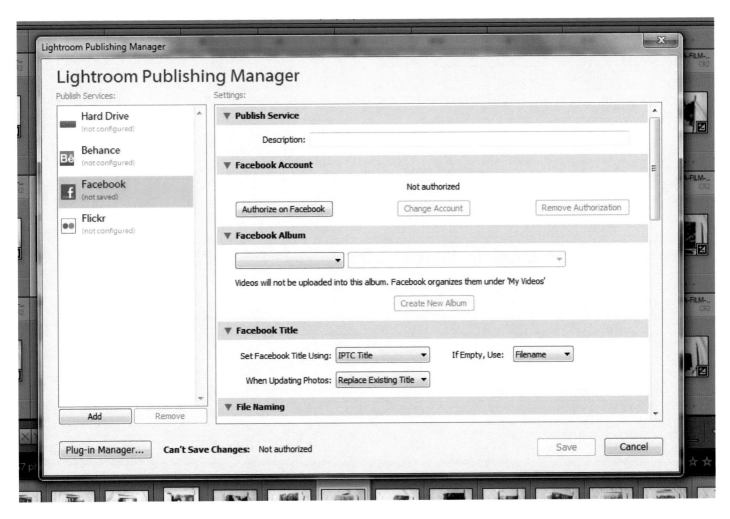

Facebook Account - Next up you will need to authorize your account. Click on the button that says Authorize on Facebook and then click OK. It will bring you to the login page for Facebook and you should enter your email/username and password and log in.

The following screen will ask you if you want to authorize the Lightroom plugin. Click Connect. A little pop-up window will appear with more mumbo jumbo from Facebook. Just click Okay and keep clicking Okay until Facebook shows you a screen saying that you have successfully connected with Facebook.

Go back to Lightroom now. Where it previously allowed you to only click on Authorize on Facebook it now allows you to Change Account or Remove Authorization. You can change these any time you want to by going to the Plug-in Manager in Lightroom and accessing this same screen again.

Facebook Album - Now you need to select the album that you want to upload pictures to. Simple enough, you just need to select the album from the dropdown menus or create a new one. In my example, I'm just leaving it in the Timeline Photos album.

Facebook Title - What do you want to title the images as? If you don't care about adding titles, then you can just leave it blank and by default Lightroom will make the filename the title of the image. For all intensive purposes on Facebook, the title is the same as a caption. So, if you leave it blank then the caption below your images will be something like _MG_28736.jpg or whatever your naming scheme is like.

If you do want to add your own title/caption, then you will need to add it in the IPTC Title field in your file's metadata. If you are unsure how to do this, flip over to the Metadata section in the book.

You can also update images currently in an album on Facebook via Lightroom. When you do this you have the option to replace the title with a new one or to leave it as it originally was. The little dropdown menu that says When Replacing Photos has those two options within it and you should select one of them.

File Naming - Do you want to rename your files before publishing them on Facebook? If so, then you should put a check mark in the empty box in the file renaming tab and select the naming structure that you want

Video - Are you adding videos to Facebook? If so, then make sure there is a check in the box for Include Video Files. Select the format you want them in and the quality you want them in. Remember though, maximum quality and the original format will create extremely large files and may take several hours to upload if you don't have the fastest connection in the world!

File Settings - What kind of quality do you want the images to be? Keep in mind that Facebook has limitations here because it is only a website and most of the time your pictures will be viewed at a very small size. I find that a setting of 80 for Quality is more than enough. If you are using a very slow Internet connection then you can limit the file size to a certain size by clicking the empty check box next to Limit File Size To and enter a number in Kb there.

Image Sizing - Again, Facebook has limitations. So, uploading a massive file will not change the appearance of it Online. By default Lightroom will resize it to fit the longest edge of the photo to 960 pixels, which is optimized for Facebook. I wouldn't recommend changing this, but if you must, then you can play around with the other options here.

Output Sharpening - Want to sharpen your photos a little bit? Since it is for Facebook and the size is not going to be very large I wouldn't worry about this option either. By default Lightroom doesn't check this box. If you really want to sharpen your images before putting them Online though, put a check mark in the box and select Screen from the list to the right of it. Standard will be fine for the amount of sharpening applied, but you can also select Low and High for less and more.

Metadata - In light of all of the thievery going on with social media these days I would highly highly highly suggest adding Copyright info to all of your photos. I do it with all of mine and it has paid off a few times when having images stolen and used for advertising purposes.

That being said, I suggest including only the copyright and contact information for your images. If you don't mind people seeing all of your metadata though, you can also select that option which would allow you to include the location the image was taken at. Sometimes Facebook will recognize the location data and will be able to pin it to the map in the Places feature they have on most people's pages.

Watermarking - Again with the whole stealing thing, I suggest adding a watermark to your images if you are a professional or even semi-professional photographer. Nothing is worse than finding an image of yours being used to make money for other people when that usage could have been avoided by adding a simple watermark.

If you are unsure how to create a watermark, please refer to the section about adding watermarks to photos later on in this book.

Finished setting everything up? Great! Click Save.

Now look at the panel on the left side of the screen again. You should see something new underneath Facebook now. Click on it. It should be empty and contain no photos now...

When you want to publish a picture to Facebook, just click and drag the picture from the grid view in Library mode and drop it on to this thing. Now, click on the Facebook thing again. You should see your picture inside of here now, but wait, it hasn't been published to Facebook yet.

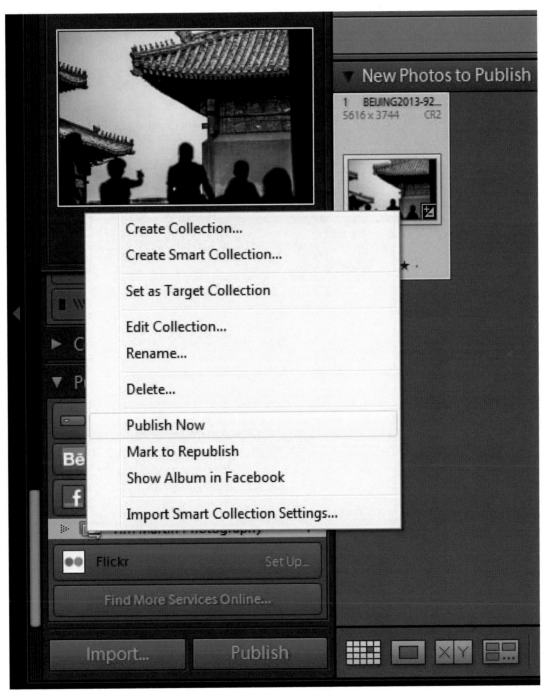

You can either click the button on the bottom that says Publish or right click and select Publish Now from the dropdown menu. After doing that Lightroom will process the picture and publish it to your Facebook account in the album specified in the earlier settings.

Viola! You're done.

If you change anything about the picture after it has been published, Lightroom will ask you if you want to re-publish the picture (as a separate file instead of replacing the original one). It should make sense when the dialog boxes come up though and I'm sure you'll be able to understand it!

RIGHT PANEL

Take a look at the panel on the right side of your screen now. At the very top you should see a tab for the Histogram. You should see four different graph-like things in here with four different colors. Gray, Red, Green and Blue. The gray colored one represents the total image and each of the colors represent their specific color channels.

HISTOGRAM TAB

All the way on the left side of the histogram represents pure black tones and all the way on the right represents pure white tones. Everything in the middle is the mid-tones. Histograms can be very useful in determining just how much and what you can do to an image with post-processing. The better the histogram, the more you will be able to do to it.

A histogram with a bell curve look, where there is not much on the far left and far right and a lot in the middle is considered to be a well exposed image and you will be able to tweak it much more than one with the "peak" of the bell at the far right or far left.

Now do you see that little box below the histogram which says Original Photo? If you click on this it will generate a smart preview of the image you are currently viewing. This will allow you to work on the image even if it is stored on a hard drive that is not plugged into your computer at the moment.

Some of the other information that is displayed on your histogram are the basic exposure elements from the time it was taken at. These include the film speed (ISO), focal length, aperture and shutter speed.

QUICK DEVELOP TAB

Saved Preset - If you have saved a lot of different presets or want to use some of the ones that Lightroom comes pre-loaded with , here is one way you can do that. It is better to do this in the Develop module, but if you just want to get a super quick preview of what the image will look like with a preset applied to it you can do that here.

Click on the box to the right of where it says Saved Preset and it will show you a menu with a bunch of different options. Select any of these and click on them to apply those settings to your picture.

Now you see that little triangle even further to the right from where it says Saved Preset? Click on that. It will expand the mini-tab and show you options for the Crop Ratio and Treatment of the image.

Crop Ratio - This is exactly what it sounds like. If you click on the box to the right of this it will show you different standard crop rations. You can either select one of the options displayed or enter your own by clicking on Custom.

Treatment - Do you want to work on the image in color or in black and white? Make that selection in the box to the right.

White Balance - If you just loaded this in from your camera then it should display as the white balance it was shot at. You can click on the box to the right and select a different WB if you want to, Try clicking on the triangle to the right again. It should expand to show you some more options for Temperature and Tint.

Temperature - By clicking on the arrows you will be able to make the picture warmer or cooler. Warmer is to the right and cooler is to the left. The single arrow triangles will adjust it only a little bit and the double ones will adjust it a lot. By hovering your mouse over the arrows Lightroom will tell you what they do.

Tint - Similar to temperature, but instead of making it warmer or cooler you can make your picture more green or more magenta in color. Magenta is to the right and green is to the left.

Tone Control - Your options here are a bit more limited. You can either use the Auto Tone button or click on the arrow to the right and manually adjust each of the different things yourself. As I said earlier, it is much more efficient to do this in the Develop module but if you really must do it here, then go right ahead.

Exposure - How bright or dark do you want the image to be overall? Click the arrows on the right side to make it brighter and the left side to make it darker. The increments are set, so you only have the choices of 1/3 stop (green arrow) or a full 1 stop (red arrow) difference in exposure when adjusting through the Quick Develop tab.

Contrast - Making the dark areas darker and bright areas brighter. Click on the right side to add more contrast and click on the left side to take away contrast and make the image appear more flat.

Highlights - The brightest parts of the picture. Click to the right to make them brighter and click to the left to make them less bright.

Shadows - These are the tones that are dark, but not black. To make them less dark click to the right and to make them darker click on the left.

Whites - These are light, but not white. Click to the right to make them brighter and to the left to make them less bright.

Blacks - the darkest tones in the image. Again, click to the right to make them less dark and click to the left to make them more black.

Clarity - Think of clarity as micro-contrast. It really has the ability to bring out details in an image but can also create some messy situations with a halo effect around the sky and objects within the image. Click to the right to add clarity and to the left to take it away.

Vibrance - This is like a smarter version of saturation. Lightroom will analyze the intensity of colors in the image and adjust them accordingly when you adjust the vibrance. Really intense colors will have less saturation added or taken away than dull ones. To add vibrance click to the right and to remove it click to the left.

Reset All - If you made a bunch of changes to an image using these clickable arrows and don't like how it looks, just click this button to

reset all of them back to their original values.

I cannot stress enough how much better it is to do these kinds of adjustments in the actual Develop module instead of here in the Quick Develop tab. You will be able to do so much more and have complete control over the adjustments instead of only being able to use a limited number of tools and preset increments.

KEYWORDING TAB

This can be one of the most powerful tools in Lightroom if you put time and effort into it. I'm going to be honest here when I say that doing it correctly and setting everything up will take a substantial amount of time, but once you are finished setting everything up it will make everything down the road a whole lot easier and simpler.

That being said, what are keywords and what are they used for? Keywords are just words that you tag photos with. The most common usage for keywording for photographers is with stock photo websites. They are what enable users to find your pictures out of the millions and millions of other photos that are available Online and can really be a deciding factor in what sells and what doesn't sell.

If you have no interest in stock photography and do not plan on searching for images within your catalog, then you can probably skip this section and end up being less confused than if you read through all of this and wonder "why the heck did I read all of that?"

For now, lets keep it in the default setting which says "Enter Keywords." We will explore the more advanced options that Lightroom offers later on in this section and go over some really cool things that Lightroom can do for you.

So, in the main keywording box you can add individual keywords to your image. Try to think of as many as you can, but make sure that they all apply to the image you are looking at.

If you are keywording an image that was taken in the Forbidden City in Beijing, then be sure to enter Forbidden City. Since it is located in Beijing, also enter Beijing and since Beijing is in China, enter China. Where is China? Enter Asia. Just try to think like this so that you can add as many keywords as possible to the image. This will make it easier to find later on no matter if you are searching within your catalog or if a potential buyer is searching on a stock photography website.

Now that you have these keywords entered to your image, lets go ahead and take a look at the Keyword Suggestions. You'll see these below the big box that you just entered a bunch of keywords in to. If this is your first time adding keywords you may not see many things in here, but if you have entered keywords for a lot of images this should be filled with a bunch of suggestions. It is definitely worth taking a look through them and figuring out if any of them are worth adding to your initial list. If they are, just go ahead and click on the word you want to add and Lightroom will add it to your list.

Below the suggested keywords are Keyword Sets. These are purely user defined and need to be set up before you can use them. They are very useful if you are always adding the same keywords to a specific type of image. For example, if you just took a bunch of pictures of tourist attractions around Beijing, you may want to create a Beijing keyword set so that you can just click on it to bring up all of those keywords.

Lets set one up and go through the process together since the first time it may be a little confusing.

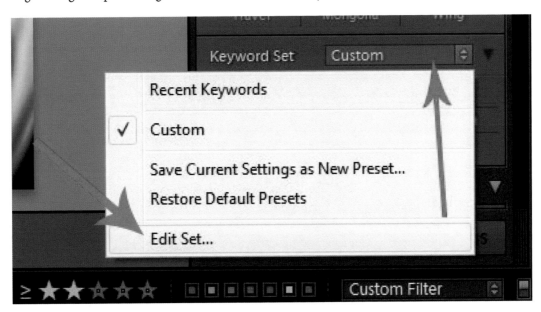

See that little box to the right of where it says Keyword Set? Click on it and click on Edit Set.

It might already have keywords filling all nine of the available boxes, but you can go ahead and just delete those. Fill in the boxes with the keywords you want to make into a set. So, for the Beijing example I am going to enter nine keywords into these boxes that are generally going to be applicable to the images.

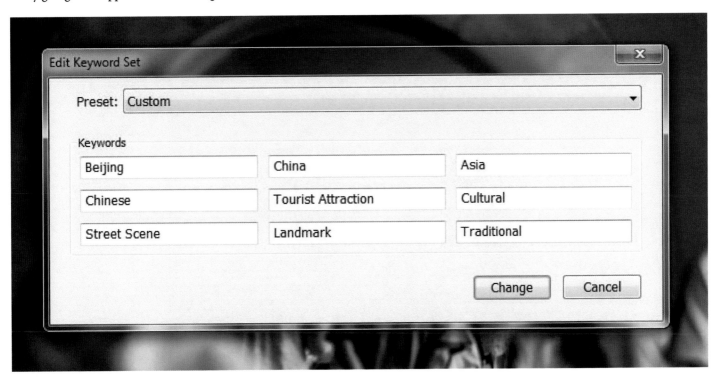

You can leave some of the boxes empty and it will not screw things up. Once you have your keywords entered, click the menu at the top of the box and select Save Current Settings as New Preset.

Enter a name that you will remember here and press Create. It will bring you back to the box you were just in, with your new keyword set all there and this time the name of the set will appear at the top. Go ahead and exit the box by clicking the X in the corner.

Great! So that is all done now. Looking back on the right side of your screen go to where you see Keyword Set again and select the one you have just created. It should be there by default, but just click it again to make sure. Do you see your keywords being displayed now? Great! Click on the ones you want to add to the image. After they have been added to the image it will highlight them in white lettering instead of the light gray color they were before. If you accidentally clicked on a keyword and want to remove it from the image that is no problem either. Just click on it again and the color of the word will go back to the light gray color.

You can create as many keyword sets as you want and they will end up being much faster and easier than typing in words to every single picture you want to keyword.

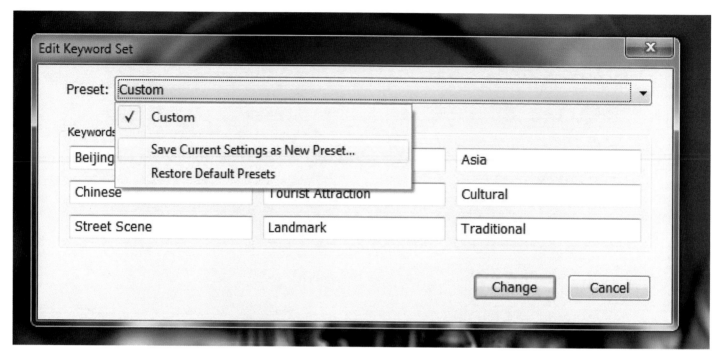

Keyword List and Hierarchy
At first glance this will look like just a list of keywords. And, while it is indeed that, there are some hidden features that you can use within it that will make keywording even faster and easier once you set it up.

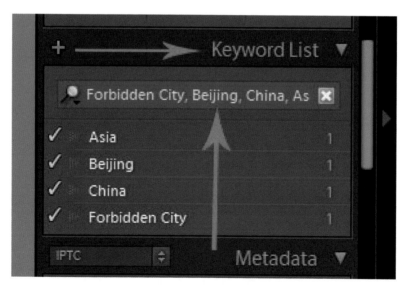

Using the same example keywords from the images in Beijing, go to the top of the keyword list where you see the search box that says Filter Keywords. Click in that box and enter a few keywords that are related. In my example, I am going to use the keywords Forbidden City, Beijing, China and Asia.

Since the Forbidden City is in Beijing, I am going to click and drag that keyword on top of Beijing. As you can see in the screenshots here, Forbidden City is now indented to the right and underneath Beijing. I am going to do the same thing for Beijing and China, and

china and Asia.

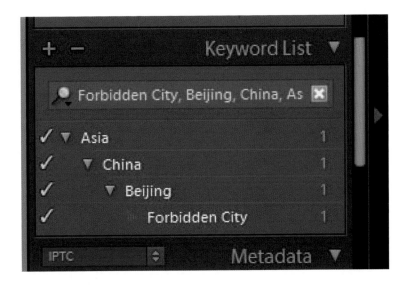

Now you may be wondering why I didn't drag Beijing on top of Forbidden City. It is purely a matter of Hierarchy. Since the Forbidden city must be in Beijing and not Beijing must be in the Forbidden City, we have placed it accordingly.

Why is setting up a hierarchy important though?

Lets go back up to the top of the Keywording tab in this panel. Do you see that box which says Enter Keywords? Click on it and select Will Export.

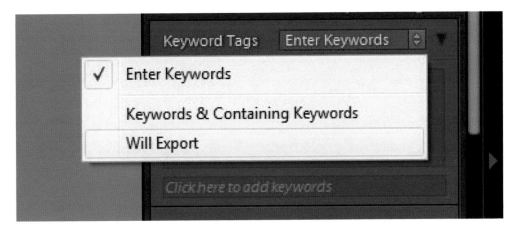

Lets go to a new photo that doesn't have any keywords entered yet. The big box should appear to be empty now. See that little box on the bottom of it that says Click here to add keywords? Click on that and enter some keywords.

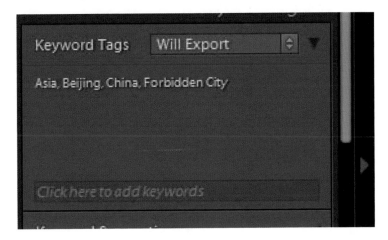

In my example, I'm going to enter the keyword Forbidden City. See how Lightroom automatically added the keywords Asia, China and

Beijing?

If you set up hierarchies properly then you will be able to keyword exponentially faster than before just by entering a few specific keywords and letting your hard work pay off for as long as you keyword using Lightroom.

Synonyms
So what about similar words? Often you will enter a keyword and want to enter all of the words which mean the same thing and potential buyers will be searching for. It would suck to have to enter all of those words manually though, and creating a new keyword set for each word and clicking on all of them is time consuming as well.

So, lets go back to the keyword list section.

Go ahead and right click (command+click for Mac users) on a keyword in the list that you want to add synonyms to and select the option for Edit Keyword Tag.

In my example I am going to add synonyms to the keyword Beautiful.

In the box that says Synonyms go ahead and enter all of the synonyms for the keyword. Be sure to separate them by commas, otherwise Lightroom will just enter them as a single long keyword. For the example, I've entered the words Gorgeous, Lovely, Stunning, Exquisite and Stunning.

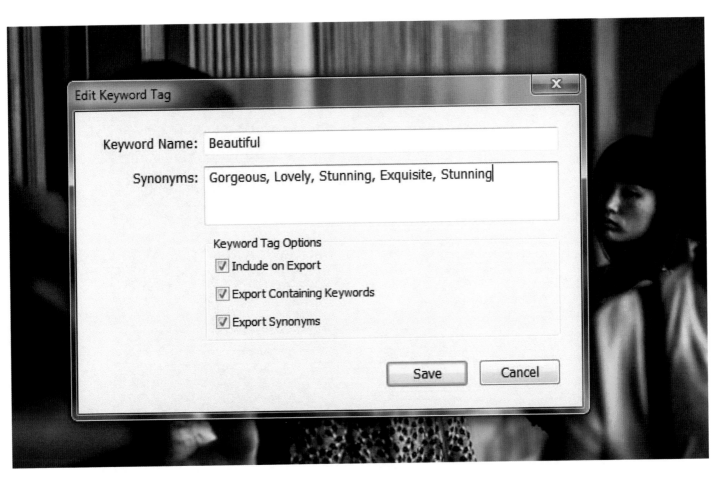

Keep all of the boxes on the bottom half of the box checked and click Save.

There, that is done now! Lets find a picture of something beautiful and make sure that it works.

Going back up to the top of the Keywording tab, lets go ahead and enter the keyword Beautiful. See how in the Enter Keywords selection it only displays the one keyword? Click and select Will Export now. Ahh, thats much better! Lots more keywords are showing up now and they are all of the synonyms that I entered before.

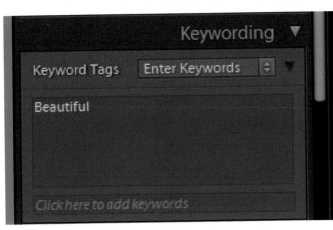
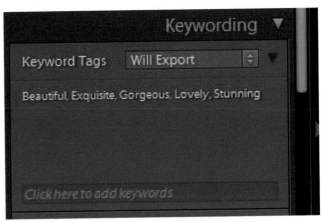

METADATA TAB

This section can also be extremely useful for photographers who do a lot of work with stock images. If you don't do a lot of stock, then I'd suggest skipping most of this section and only learning about adding a copyright to your images.

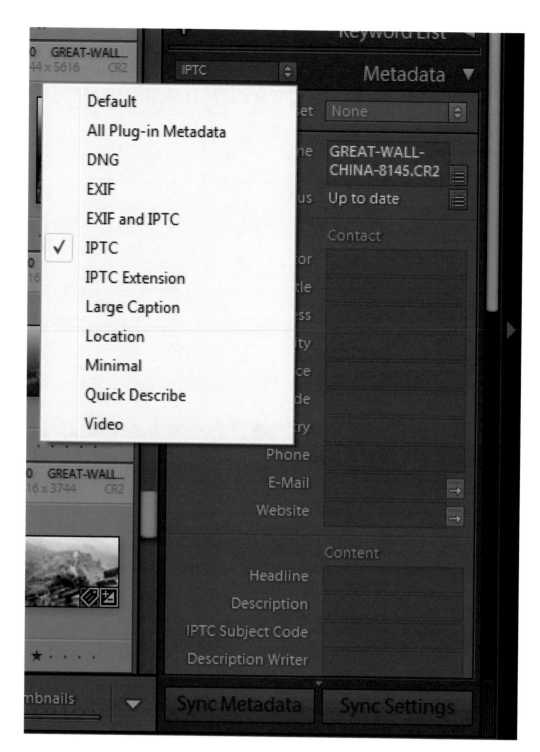

There are a ton of fields in here that you can fill out and each one of them will be important to some person or another. Since metadata is very well covered Online and there are many great resources out there to help you figure out which fields to write things into I will only go over the basics of it and go over creating a preset for your copyright.

That being said, lets take a quick run through the different options for metadata fields. Lightroom should be showing Default in the little box to the left of Metadata right now. Click on that and you will see a big range of options. Most people who have used Bridge before should be familiar with IPTC and EXIF. The IPTC option is where you will enter most, if not all, of the metadata you need.

The fields are fairly self exclamatory here. For example, under the part that says Contact there are plenty of fields available for your contact information. If you have any questions regarding entering metadata I recommend checking out the help section on Adobe's website. They do a pretty good job of explaining what each field does and where to put things.

Copyright
This will be down at the bottom of the IPTC field. You should see a little section that says Copyright and four boxes below that.

Copyright Status - The first box is a dropdown menu where you should select the copyright of the image. Your choices are Unknown, Copyrighted and Public Domain. Unknown is the same as just not entering any information and leaving that field blank, so I recommend not using that one unless you honestly don't care and want to ignore copyrighting your images altogether. Copyrighted is what it sounds like. Plain and simple. Public Domain is for people who want to share their images and let other people use them as they wish. It is like putting a "Free" sign out at a garage sale for your pictures. All of the images used on Wikipedia, for example, are public domain.

Copyright - Once you've made your selection there, lets go to the next box for copyright. Here, you should enter your name (or company name) and the copyright symbol.

Rights Usage Terms is an optional field for most people. If you set your image to Public Domain but do not want it to be used for advertising toilet paper in a TV commercial, then write that down here. Basically you should put the terms of usage by other people in this box.

Copyright Info URL - There are a number of websites dedicated to photographers' rights and many of them have a specific page which lays out information regarding the copyright of images you have taken. If you want to, search Google for some of these sites and paste one of the URL's into this box.

Once that is all done, lets save a preset for your copyright information so that you don't need to enter it again.

Scroll all the way back up to where the Metadata tab stars. Do you see the little thing that says Presets? Click on that and select Edit Presets from the small dropdown menu.

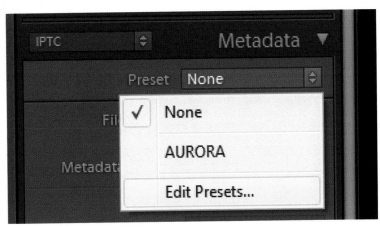

It should bring up a big window that has a ton of options within it. Scroll down until you see the part that says IPTC Copyright and put check marks in the empty boxes on the right side next to the parts you want to include in your saved preset.

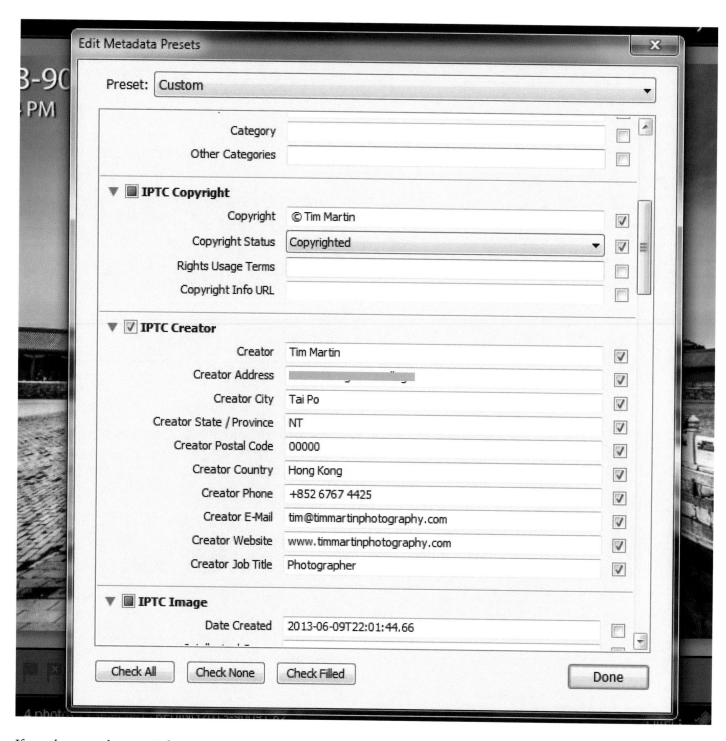

If you also entered contact information you should scroll down a little bit more and put check marks in all of the boxes you entered for your contact info.

Once that is done, go to the top of the window and look for where it says Custom. It should be at the very top. Click on that and select Save Current Settings as New Preset.

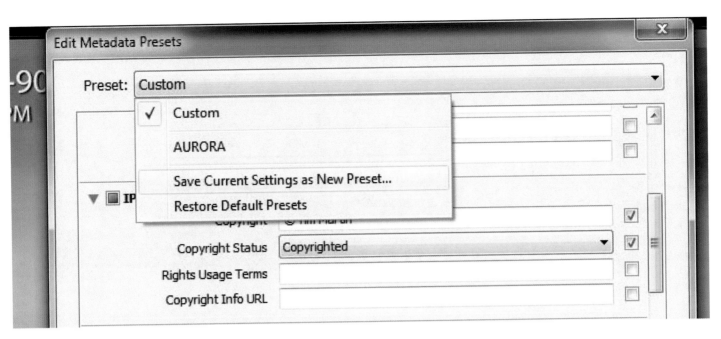

Write out a name you'll remember like 'My Copyright' or something like that and save it. Now you won't have to enter that information ever again and just need to remember to apply it to all of your images upon import!

So, why is adding a copyright to your files important? For one, it is the first line of defense against having your images used illegally. If things get really bad and you end up going to court you will be able to show them a RAW file with the copyright and contact information in it.

COMMENTS TAB

This section only works with photos which have been published on Facebook or Flickr or another service which you have set up. For the Facebook one it will display comments that other people have made on your pictures and the number of Likes it has. You can directly reply to their comments via Lightroom if you want too, which I think is pretty cool!

FILMSTRIP BREADCRUMBS

See all of that extra stuff on the filmstrip above the photos? Each of these icons does something and you should try to familiarize yourself with them.

MAIN WINDOW

Check where the blue arrow is pointing. It should be a 1 inside of a little box. This is for the main window in Lightroom. If this is highlighted and appears to be more white than the other little icons around it, that is normal. Don't worry about it!

If you want to go to a different view mode (Grid, Loupe, Compare, Survey) then you can click on this icon and select the appropriate view from the list that pops up. From here you can also enter and exit fullscreen mode.

SECOND WINDOW

If you are using multiple monitors for your computer or like to multitask on a lot of different things, the second window can be a very useful tool. Go ahead and click on the icon with the 2 inside of the box, the one the red arrow is pointing to. Did something pop up on your screen? Great!

Ok, some things about the second window that you should know about before clicking on too many things.

It is very limited in what it can do. Basically, the sole purpose of the second window is to display images in each of the four view modes on a separate part of your screen than the main window in Lightroom. If you are using a laptop or a single monitor, this will not be a very useful feature.

The second window has no panels or tabs. If you want to change something about the image, just go to your main window and make the changes there.

You can drag the second window anywhere on your desktop, but it will always always always appear on top of the main window. So, if you want to click on something that is hidden behind the second window you will have to move it out of the way first.

Great, so, what can this thing do?

VIEW MODES

See the four of them at the top left side of the window? They do the same things that they do in the more normal way of viewing images in Lightroom. Grid displays a contact sheet, Loupe displays a single image, Compare compares and Survey surveys! Easy enough, right? All of the tools that you know about for the different view modes also works here.

For example, if you wanted to switch the position of images in Compare View, then you would just click the icon for swapping their positions around the same as you normally would,

Grid View, compare View and Survey View should all be easy to you and nothing to really add to them.

Loupe View has some extra functions in the second window that you should know about though. Go ahead and click on Loupe in the second window and take a look at the top right part of the window. Do you see those three new options that are not there in the main window?

NORMAL

This does exactly what it sounds like it does. If you have this selected, then Loupe View in the second window will behave exactly like the Loupe View in the main window and will just mirror everything going on there.

LIVE

Lets pretend that you have the second window on a different screen and want to very quickly take a look at another picture but don't want to deselect the one you have selected in the main window. With the Live feature here it is possible. Basically, any image that your mouse is hovering over will be shown in the Loupe View in the second window. Try it out for yourself by moving your mouse along the filmstrip in the main window and watch what happens in the second one. Cool, right?

LOCKED

Opposite of Live view, the Locked view will only display the image that is most selected when you click on Locked. So, if you are looking at a picture of a dog and click Locked, then start moving around to other pictures in your main window, the picture of the dog will still be showing in the second window until you switch to Normal or Live.

SELECTION

Back to the beginning of the Filmstrip Breadcrumbs though, do you see where the yellow arrow is pointing to? In my example screenshot it should say something like 'Previous Import' and then 30 of 167 Photos/1 Selected/BEIJING-9012.CR2. The information here is just telling me that I am looking at pictures from the previous import collection, there are 30 out of 167 images being shown (with the others hidden because of a filter) and that the current image is BEIJING-9012.CR2.

If you click on any of the words in here it will bring up a list of other sources that you can go to without clicking on something in the Left Panel.

The biggest section of the list will probably be the Most Recent Sources and it will display the most recent collections and folders you accessed. If you want to clear these, then just click on the last item on the menu.

TAGGING AND RATING IMAGES

Now that you have images loaded into LR and have already gone through the process of importing and renaming them. Keywords added? Great! Now lets get down to business.

The first step in post production should always be to filter out the good from the bad. Personally I use flags as the very first step, but many people also jump directly into the star-ratings. Ultimately it just comes down to finding a system that you are comfortable with and will be able to repeat every time you go through the process.

FLAGS

There are three different flags you can use. Rejected, Unflagged and Flagged. Fairly simple, right? Flagged images, or "Picks" as Lightroom likes to call them, are labeled by a white flag in the top left corner of the thumbnail on grid view. Unflagged images, meaning they have no flag status applied to them, will have nothing in the corner. Rejected images will be marked by a black flag with a white X inside of it and the thumbnail will go to half opacity. You can see all of this in the screenshot below by looking where the three red arrows are pointing. If you simply want to remove a flag from an image, just hit the U key and it will return to being unflagged.

Lightroom has a really nifty feature where you can take all of your rejected images and delete them with a couple clicks of your mouse. To do this, just go to Photo in the menu up top and select Delete Rejected Photos (at the very bottom of the menu). It will then ask you if you want to remove them from the catalog or delete them from your hard drive.

The shortcut for deleting all rejected photos is Control+Backspace (Command+Backspace on a Mac)

Keep in mind that if you click Remove, it will only take them out of the catalog and you will no longer see them in Lightroom. The photos will still be taking up space on your hard drive though. If you select Delete from Disk, it will remove the files from Lightroom and then put the actual image files into your recycle bin.

TIP: The hotkey for setting an image's flag status as Rejected is ` and the shortcut for marking an images as a Pick is P. Also, to change the flag status you can hit Control+(Up Arrow) or Control+(Down Arrow) to increase and decrease their status respectively.

STARS

Now that the junk is all gone, lets start finding those good snaps from the lump of untouched images. I highly recommend starting out with 1-star ratings for the first round of selects. To add a star just hit the 1 key on your keyboard. You'll see a little rectangle pop up when you do this that says "Set Rating to 1" and will know its been done.

In the grid view you can see the star ratings at the bottom of the thumbnail of each picture, like in the screenshot above.

You can also see the stars in the filmstrip at the bottom of your screen as in the screenshot above.

Run through all of your images for a very loose edit first. Anything you like, even if only a little bit, set it to 1 star. Usually your first impression will be good enough for this, so as long as the image is even somewhat good or has a nice smile or a cute moment in it, mark it with a 1-star rating.

Now that you've gone through from the first to the last picture, go ahead and sort images by rating by clicking on the first star from the left above the filmstrip. Please refer to the screenshot for a more precise location of where to click!

Lightroom should now show only the 1-star selects. Run through them again with a 2-star rating. Do this by hitting the 2 key. Run through it a couple times if you are not very confident or want a second look at some images. I do it all the time, usually going through 2-3 times for each step for ratings.

Sort your images by a 2-star rating now. Rinse and repeat the same thing for 3, 4 and 5-star ratings After three rounds of selects you should now have a pretty solid collection of images that are ready for some retouching!

Usually I will just go through 1, 2 and 3-star ratings and then will apply some develop settings on the images before deciding which ones to rate higher at the 4-star and 5-star levels. Everyone has a different system though, so just do whatever feels best for yourself!

COLORS

Lightroom, like Bridge, also has the option to use colors to identify images. There are quite a few choices, but the primary ones are Red, Yellow, Green and Blue. The shortcuts for these are 6, 7, 8 and 9. You can also choose Purple as a color by right clicking (Command+-Click for you Mac users) and going to Set Color Label then choosing it from the list.

Below is a screenshot of how images will look when they have a color label applied to them.

To remove a color label from an image, just hit the same shortcut that you hit to apply the color or right click and select None from the list of available color label options.

SORTING AND FINDING IMAGES/LIBRARY FILTER

Back to the grid view in Library mode. If you are not sure if you are there, press the G key on your keyboard. This is the shortcut to get to the Grid view. Ok, do you see anything on the top of the screen that says Library Filter with a bunch of other stuff?

If not, then press the backslash key (\). This is the shortcut to show and hide the library filter from view. Can

You will not be able to see the Library Filter if you are in Loupe view and displaying only a single picture, so make sure that you are in grid view.

What does this filter do? For one, it enables you to sort your images by almost any means you can imagine.

TEXT

Lets start with the first main section of the Library Filter and click on Text. You should see a couple of boxes that are grayed out right now. By default they should be Any Searchable Field and Contains All and to the right of those will be a box that you can enter words into. If you keep these settings the same and then enter a search word into the box on the right it will find and retrieve files which have that word anywhere in them. It can be part of the filename, inside a description in the metadata or anywhere else and will display a very broad selection of results.

Lets narrow it down a bit though. Click on the box that says Any Searchable Field and it will bring up a range of options. Select the one that you want. For example if you know you added a description to a photo with a specific word in it, then select Caption or Searchable IPTC. Both of these will include the caption/description field. After selecting that, click on the search box to the right and enter your word or words.

If you are a bit unsure if you entered China or Chinese, then put both of them into the search box separated by commas. After doing that, click that middle box and select Contains instead of Contains All. It will show you all of the photos with the word China OR Chinese in the description field.

Play around with the options in these boxes and you will be able to find almost any picture you have entered data for.

Similarly, if you only renamed the file upon import and never added keywords or other IPTC data to it then you can select Filename from the list on the left and then search for the word. It will show you all of the pictures which contain that word within the filename.

ATTRIBUTE

Searching by attribute is one of the most common things you'll do in Lightroom when trying to narrow down the number of images you want to look at and there are a bunch of different ways to do this.

Lets start on the left side of the filters for this. Do you see those things that look like outlines of flags? In Lightroom lingo they are actually called flags. The one on the left is a pick, or flagged image, the one in the middle is unflagged and the one on the right is a rejected flag.

If you have flagged your photos as rejected or as picks before then this can be a very useful thing.

If you want to display only pictures with the rejected flag then click on the one to the right and the grid view will display all of the pictures which have been marked as rejects. If you want to show images which are unflagged AND flagged as picks then deselect the rejected flag and click on the other icons.

To deselect an attribute filter, simply click on whatever was highlighted before and it will go back to being grayed out. Once you do that, it will display your results without applying that filter on the images!

Star Ratings
These should be fairly straightforward. The little icons of stars that you see? Click on the first one on the left side of the image. This will show you all of your images with one star and higher. Click on the second star. Now you can see that Lightroom is only showing you pictures with two stars and higher. Three, four and five work the same way. Simple, right?

You can do more than just this though. Do you see the symbol to the left of the first star? By default it is set to the symbol for "Greater than or equal to." Click on that symbol. You should see three options there now. If you select Less than or equal to then Lightroom will only show you pictures which have the same star rating that you clicked on and pictures with ratings less than that. If you click on Equal to then it will only show you pictures which have that exact rating and nothing else. Pretty easy, right? Play around with it and make yourself comfortable with using this tool.

Colors
Colors are another way that you can sort through your images in addition to flags and ratings. There are seven different options here;; Red, yellow, green, blue, purple, custom and unlabeled. Very simple to understand this sorting function, you just need to click on a colored square to have Lightroom display all of the pictures with that color label. If you want to show multiple color labels, then click on multiple colors.

Again, to remove a color from the list that is showing, just click on it again and Lightroom will remove those from the display.

Kind
Three options here. To be honest, I almost never use this sorting function unless I am trying to find a specific video file which is in my Lightroom catalog. Your options are master files, virtual copies and videos. Master files are the RAWs or JPGs or PSDs or whatever you originally imported into Lightroom. These are the base files. Virtual copies are duplicate ghost copies that you created in Lightroom and not the original source file. Videos are, as you would expect, video files.

Lock
On the top right of the Library Filter you should see a little icon of a lock. Click on this to either lock or unlock the filter settings. When it is locked, the filter settings will stay in place when you move to a different source for the images you are viewing. What that means is, if you are viewing photos on your internal hard drive with a sorting filter applied and then switch to viewing pictures on an external hard drive, the sorting filter will still be there and you will be viewing the images on your external hard drive which meet the same criteria.

If the lock is unlocked then whenever you change sources all of the filter settings will be reset and you will be viewing all of the images from that source, no matter if they have ratings, stars, flags or nothing at all.

Filter Presets
Same as with almost all other settings in Lightroom you can create and save presets for filtering your images. If you have a specific structure with your metadata and stars and ratings and everything else and don't want to manually re-create that filter each time,

Look just to the left of the lock. Do you see something that says Custom Filter? Click on that and select Save Current Settings as New Preset. Make a name for it that you will remember and click Create. Now those settings will be there forever! The next time you want to sort by the same criteria, just click on that same box that says Custom Filter and select the preset that you just saved and Lightroom will do all of the work for you!

METADATA

You can search every single field in your metadata here. Cameras, lenses, titles, keywords, focal lengths, ISO, you name it. Everything! There are four separate field that you can filter by at the same time. Do you see where those are at? The metadata filter tab is divided into four separate parts and each section can show different attributes for an image. Click on the bar at the top of each section to select the applicable metadata field and Lightroom will display all of the options for that field underneath it.

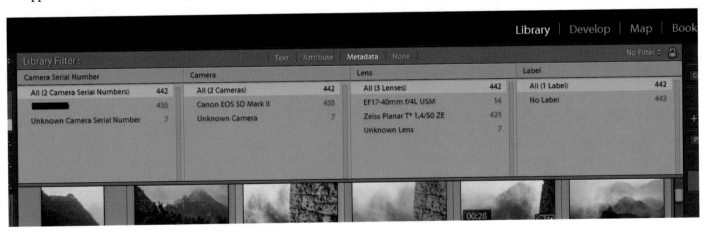

For example, if you are filtering by focal length, it will show all of the different focal lengths for the pictures which are included in your selected folder and the number of images which have those focal lengths. It may sound a little bit tricky when I write it out into words, but just try it on your computer and you'll see what I mean.

Do this for all four sections here and you will be able to narrow down your pictures to a very small and defined selection!

TIP: If you are in the metadata section of the Library Filter you can also click on Attributes and you can apply those as well. So, in theory, you can filter through your images with four separate metadata fields, flags, ratings, colors and file types all at the same time!

It is a really powerful tool when used correctly and can save you huge amounts of time finding and refining selections of pictures without having to manually go through every image in your folder and adding your selections to a quick collection.

Check out these screenshots to follow through my process of selecting video files which were taken in Ulaanbaatar, Mongolia with a

specific camera and focal length that also have stars and colors added to them.

NONE

If you click on the thing that says none (last of the four options on the top) then it will remove all filters and show you the grid view of all of the images in your selection.

COMPARE VIEW

Another cool feature that Lightroom has is the ability to compare two images side by side. Check out the screenshot below to see what I mean and I will explain further below the screenshot.

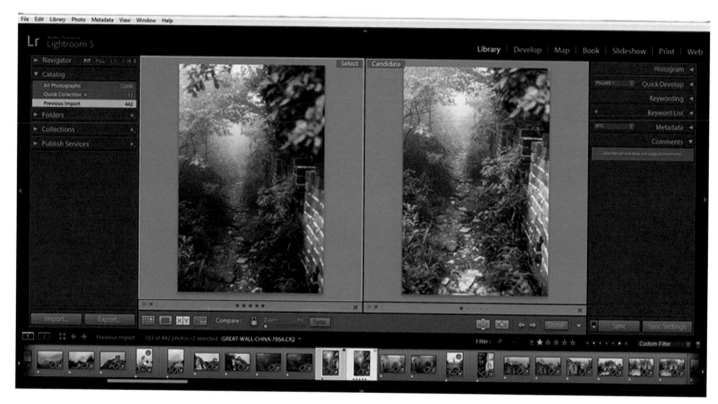

To enter compare view just select two images and hit the C key on your keyboard. To select multiple images you can either Control+-Click (Command+Click on Mac) or select one image and hold down your shift key and use the arrow left or arrow right key on your keyboard at the same time.

This view is really useful for a lot of things, especially if you are doing a lot of retouching on your images or want to see which image is better when two of them look exactly the same.

Do you remember the viewing options in the navigator tab? You can use those in compare view as well! Try it out by clicking FIT and you will see that both images now fill their respective parts of the screen and leave no background space empty. You can do this with any of the view options.

For comparing the critical focus on images, just go to the 1:1 view by either clicking on 1:1 in the navigator or by clicking your mouse inside one of the images to zoom in to 100%. Both images will zoom to the same spot within the image. This is really useful if you took the pictures from a tripod and the framing is exactly the same. If the images are from a slightly different perspective you can still make use of this because the elements within your picture will be generally similar.

So, which image is on the left side and which one is on the right side? Do you see where it says Select and Candidate at the top of your screen?

You can change these images around so that the one on the left becomes the one on the right and vice versa. You can also swap out to different pictures for the select position.

To do this is pretty simple actually. Take a look at the filmstrip on the bottom of your screen. Do you see how one image has a white diamond at the top right corner and another has a black diamond in the corner?

The image with the black diamond is the candidate and will remain consistent no matter how many different images you swap out for the select. Try clicking on one of the other images in the filmstrip. Do you see how that one is now the select and your candidate has stayed the same?

So, some other things you can do while in compare view.

A lot of little arrows in this little area! So, what do each of them do?

Lock - The red arrow is pointing at this thing. If you click on the lock and see it become unlocked, then you can move around and zoom separately for each image. This means they will not be synced together. It is useful to unlock an image while in compare mode if the focal point is in a different location in each image. After moving around and zooming separately, you can always lock it again and

it will keep those same settings in place for the image on the left side (the select) and will make the settings for the candidate image the same.

Zoom - Check the slider bar where the blue arrow is pointing to. The zoom slider bar works exactly as you would expect it to, with the far left side being zoomed out and the far right size zooming way in.

Fit - Little white arrow above the slider bar for the zoom. This just displays the zoom ratio of the image you have selected.

Sync - Check the green arrow. If your images have been unlocked and moved or zoomed separately you will be able to use this function. It will apply the same zoom and location settings on each image. If you have not unlocked the images, they will by default be in sync.

Swap - Where the pink arrow is pointing to. You see the X | Y thing with arrows pointing both ways on the top and the bottom? If you click on this it will swap the positions of the select and candidate.

Make Select - Yellow arrow, the X | Y thing to the right of the swap button. If you click on this it will make the select become the candidate and choose the next image down the line (to the left on the filmstrip) as the new select.

Select Previous/Next Photo - The little arrow buttons just a bit further to the right. Check where the cyan arrows are pointing to in the screenshot. If you click the left pointing arrow it will make the previous image the new candidate and if you click on the right pointing arrow it will make the next image the new candidate. Fairly simple, right?

Done - Simple enough. When you are done comparing photos, just click on done! It will exit the compare mode and return you to the screen you were in before.

SURVEY VIEW

Another nifty mode that Lightroom has is Survey View. With this view mode you are able to compare any number of images you want in a contact sheet and rate, flag and remove images from the view mode in order to find the best one (or ones!).

Lets start off by selecting a bunch of images in your grid view. If you're not there already, just hit G on your keyboard. Select a bunch of images which are similar and that you want to see together by Control+Click (Command+Click on Mac). Have them all selected? Great!

Now, press the N key on your keyboard! Or hit the survey view button at the bottom left of your screen (Check the red arrow in the screenshot below).

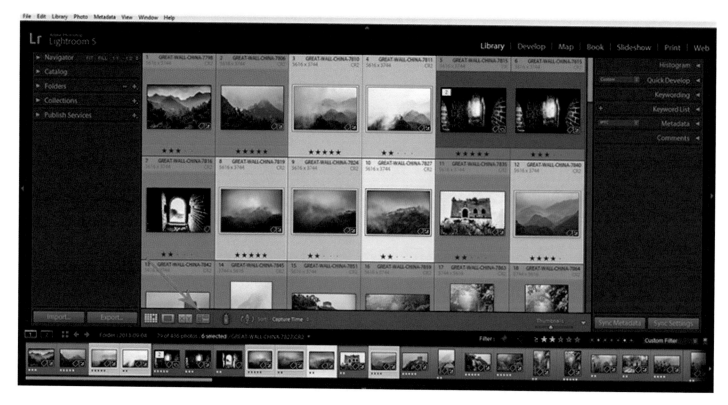

Okay, now that you have entered Survey View, lets get down to business with what this feature is all about. So, you can see your images displayed in the center of the screen. Lets get rid of your panels and the filmstrip to give those pictures some more real estate. Hit Shift+Tab at the same time on your keyboard and then hit T to get rid of the toolbar. Does it look better and bigger now? Great!

So in my example I have selected six images and you can see that they are all of roughly the same subject and are displayed nice and big on the screen. So, what exactly can you do with these images now that they are in Survey View? For one, you can add flags, star ratings and color labels to them. Click on one of the images. You should see a white rectangle show up around it. Whichever image is inside of the white rectangle is the one which is selected and you can apply changes to. You can use the arrow keys to move the rectangle around and select images while inside Survey View.

So, lets say you want to mark something as a pick or a reject. While it is selected, you can either use the shortcut keys of P for pick or X for rejected. Easy enough, right? Same thing with the star ratings. 1-5 all apply here too. So what about color labels? If you know the shortcuts for each color, then use those (6, 7, 8, 9 for Red, Yellow, Green and Blue) or you can make use of the color label icon below the image. Check out the screenshot below for some help in this department... The red arrow points to a flag picker, the green one to the star ratings and the blue one to the color picker. If you click on the very difficult to see rectangle below the bottom right corner of the image it will pop up with a little menu of different color labels for you to select.

See that yellow arrow in the screenshot? It is pointing to the very obvious elephant in the room. The X. If you click on the X for an image it will remove it from Survey View and Lightroom will adjust the remaining images for optimal screen space if it needs to.

When narrowing down a selection of images, the X can prove to be quite useful because it will not change anything about your image. The ratings, flags and colors all stay exactly the same as they were the instant before taking it out of Survey.

One more thing you can do in Survey View is move pictures around. Just click and drag the picture you want to move to the location you want it to be at and Lightroom will move it. You can only do this if you are viewing images which were selected from a folder or a collection. If you are viewing them from a smart collection or your previous imports it will not work.

So, lets say that you have made all of your decisions and are left with only a few images on your screen now. You can either give them all an identifying color or flag them as picks, or simply exit the Survey View by hitting the G key or clicking on the icon for Grid view.

You'll notice that when you go back to the grid view, all of the images you had narrowed your selection down to are still selected. From this point it is really easy to add them all to a collection or batch keyword/metadata process them.

EXPORTING IMAGES

Take a look at the left panel in Lightroom, down towards the bottom where it has a big button saying Export. Click on that. Or if you are lazy like I am, just hit Control+Shift+E (Command+Shift+E on Mac) and it will bring up the same Export dialog box.

One thing to note with Lightroom is that exporting images will not be a super quick thing if you are working with very large files and large numbers of them. It needs to open the source file, apply and render the develop and metadata changes you have made and then resize and save them in the format you specify. So, if you are trying to export 1000 family vacation pictures it will take a bit of time.

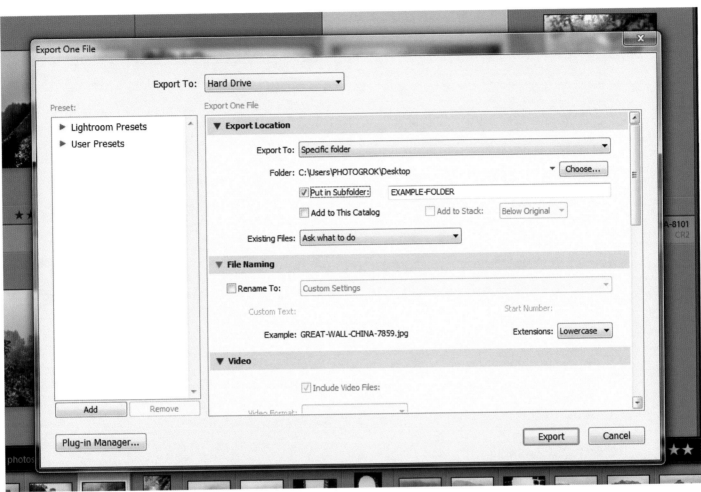

Starting at the very top of the dialog box do you see where it says 'Export To:'? That is usually the option that you will want if you want to export the images to your Desktop, an external hard drive or even a USB stick. Another option is E-Mail, which will export the images and load them as attachments to Mail or Windows Live Mail or whatever email system you use on your computer. The last option is CD/DVD in case you are still living in the year 2004 and want to write your files to one of these discs.

Since 99.34% of you probably want to export to your desktop or a hard drive, that is the one I will guide you through in detail. So, moving on...

EXPORT LOCATION

Where exactly do you want the new files to be once Lightroom is finished exporting them?

EXPORT TO

Specific Folder is usually the best way to do this because it will get the location out of the way at the very beginning. Do you want them to go to your Desktop? To a USB drive? To somewhere else hidden away within a folder on a hard drive? Select 'specific folder' and then click on 'Choose' at the right side of the export box on your screen. Select the location you want and click Select Folder.

The other options in this setting are the original folder, which is where the RAW files are at, or to choose the folder location after im-

port, which will prompt you to choose a location shortly after.

PUT IN SUBFOLDER

Does the folder you want to export images to not exist yet? You can put a check mark in the box that says Put in Subfolder and write out the name of a new folder. When Lightroom starts exporting the images it will create a new folder by that name and put the images inside of it.

ADD TO THIS CATALOG

Usually you will want to leave this box blank. What it will do if you have it checked is add the new JPG or DNG or whatever format you are exporting as back into the catalog. This will create duplicate copies of the image on your hard drive and in your catalog. If you really want to do this though, and I'm sure some of you do, then by all means go for it.

EXISTING FILES

If you are exporting pictures into a folder that already has pictures in it, it usually will not be a problem. If those pictures have the exact same file name as what you are exporting though, this box is going to play a big role. By default Lightroom has the 'Ask what to do' option selected, which means it will ask you if you want to overwrite the existing files or give the new pictures a unique name (usually by adding a -2 at the end of the filename).

The other options that you can choose here are to choose a new name, overwrite the existing file (with a warning) and to overwrite the existing file without any warnings. I would highly recommend just leaving this setting with the default that Lightroom gives it.

FILE RENAMING

Giving your files a new name when you export them is much simpler and faster than manually renaming them later or dropping them into Bridge to do a batch rename (Lightroom can do that too by the way). So with that being said, how do you rename files upon export?

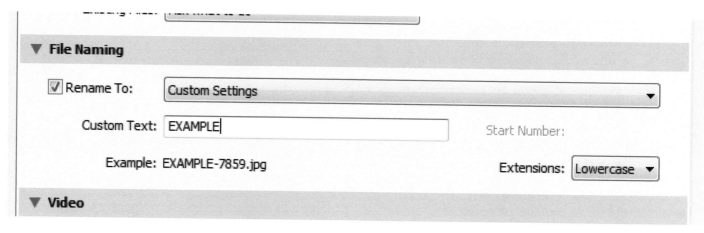

Lightroom will only rename your files if you have a check mark in the box. So if you don't care about it, then just ignore this tab and move on to the next one.

CUSTOM SETTINGS

If you do plan on renaming files, check the box and click on the menu to the right of it. Select Edit... and it should bring up this screen but without anything selected yet.

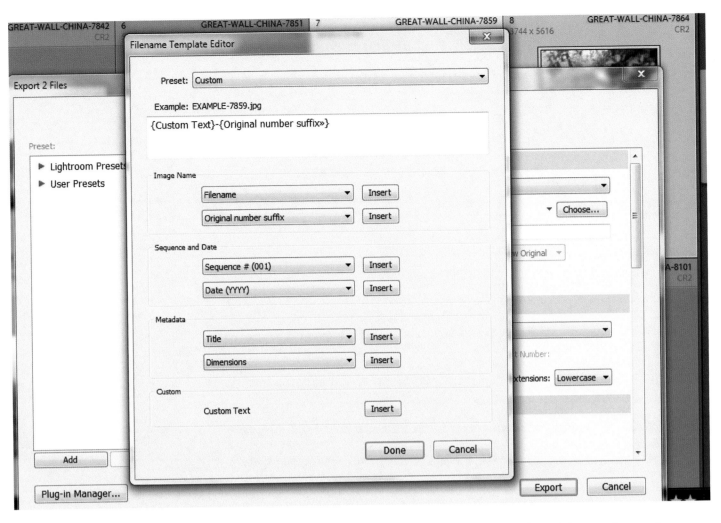

When I export files I like to keep the original file number with it in case I need to find it again years later. Other people use other systems and organize everything with their initials or name and the exact date or whatever else they want.

Using all of the options in the dropdown menus in this box you should be able to come up with something that will work for you. Play around with it for a while and set one up. Once you've done that, just click Done at the bottom right.

TIP: You can save your custom file naming conventions as a preset so that you can use them again later on without having to do any hard work. To save it as a preset, just click on the top menu in this box and select the option to save it as a preset.

TIP: Above the white rectangle that shows what components are going into your filename you can see an example of what the files will be named like when they get exported. Checking this should help to clear up any confusion about what certain terms will look like or how they will be formatted.

EXTENSIONS

Mostly for OCD people, but do you want the file extension to be .jpg, .dng, .tiff or .JPG, .CR2, .TIFF? Lowercase will give you lower case and upper case will give you upper case. Super simple.

VIDEO

If you have video files and want to export them you will need to put a check mark in this box. If you don't, then Lightroom will ignore them and export only image files.

VIDEO FORMAT

For the format of video files Lightroom doesn't really have many options. You choices are DPX, H.264 and the original format (which will vary depending on which camera you used to shoot the video files).

DPX is mainly used for higher end video editing programs. If you plan on editing your video files in an external program anyways, Lightroom is not going to be very useful for you and exporting and rendering any changes made in Lightroom will take vast amounts of time. That being said, Lightroom is capable of doing some basic video editing for color effects and exposure/contrast. So if you want to do basic changes in Lightroom and then export it as a DPX file so you can edit it in a different application. These files are incredibly big as well, so be warned!

H.264 is a much more standard video format that can have a range of different extensions at the end of it. In the case of Lightroom, the H.264 will export as a .mp4 file which is readable by pretty much any device or computer out there. So if you want to export video files to upload to YouTube or Vimeo or send to your friends and family, I'd suggest using this one.

Original is exactly what it sounds like. If you export the original format Lightroom will not apply any changes to it that you made using the Quick Develop options and it will essentially make a duplicate file of the original one in a different location.

QUALITY

Different video formats have different options for the quality. For DPX format you have the options of 24fps, 25fps and 30fps, all of which are common quality rates. I'm assuming that if you are using DPX you will know which one of these you need to use. If not, Google is full of wonderful websites which can help you choose the right one for your intended final usage of the video.

For H.264 your choices are much easier to understand thanks to the helpful little text that shows up underneath and to the right of the quality menu. Do you see it in the screenshot above? The information to the right will tell you the resolution of the video and how big it will be in terms of Mbps. The information below it tells you what kind of things the given quality is good for. Pick and choose whichever one works best for your uses.

FILE SETTINGS

Plenty of different options to tweak in this tab for all of the file settings.

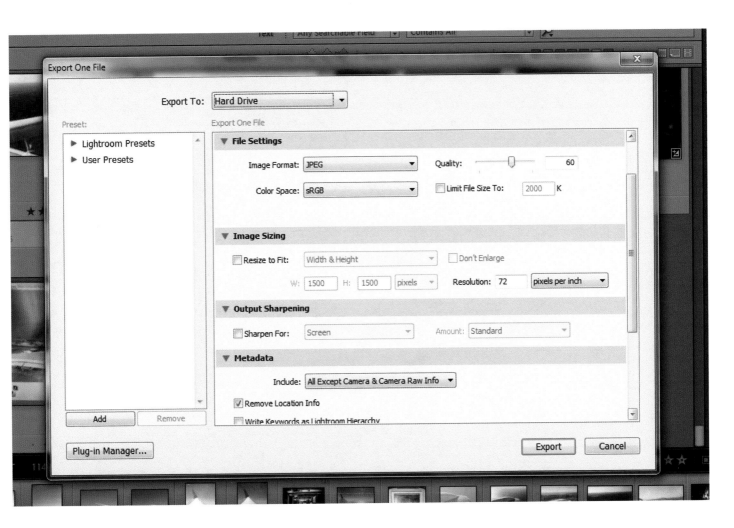

IMAGE FORMAT

The first thing you will need to decide is what format you want to export your picture as. If you are just using it for website usage or to share in an email or store a low resolution copy on your Desktop then JPG will be more than okay.

Other file types that Lightroom is capable of exporting as are TIFF, PSD, DNG and the original format (if you shot in .NEF or .CR2 or whatever other RAW format your camera shoots in, the original format will be the same as that.

JPG FORMAT

For JPG files you will be able to choose the quality of the file in terms of a percentage. 100 is the best and 0 is the absolute worst, with 100 producing a large file and 0 giving you a very small file size.

You can limit the file size of the JPG by putting a check mark in the box that says Limit Size To and entering a number there in kilobytes. For those who are unsure what to put, if you write down 1024 it will make the maximum file size 1MB.

Color space will decide what color profile your picture will have. The most common ones are sRGB, which is used primary for websites, AdobeRGB (1998) and ProPhoto RGB, which keeps more data for colors than the other profiles do and is best for printing. If you like to use a different color profile that Lightroom doesn't have already it is very simple and easy to add it by clicking Other from the drop-down menu.

PSD FORMAT

For PSD files you will not have any choices for the quality and Lightroom will save it at the native quality. If you select this option the only choices you have are the color space and bit depth.

With bit depth your choices are 8 bits/component and 16 bits/component. With the 8 bit setting you will have a smaller file size and less data for the colors and 16 bits will give you bigger files with more color data. The end usage of your picture will probably have a big role

83

in deciding which one of these to use.

TIFF FORMAT

For TIFF files your options are for compression and the choices are none and zip, with none giving you an uncompressed file (better for external editing) and zip compression giving you a slightly smaller file size without losing too much quality.

DNG FORMAT

With DNG files the quality options change around to a different set which is shown in the screenshot below.

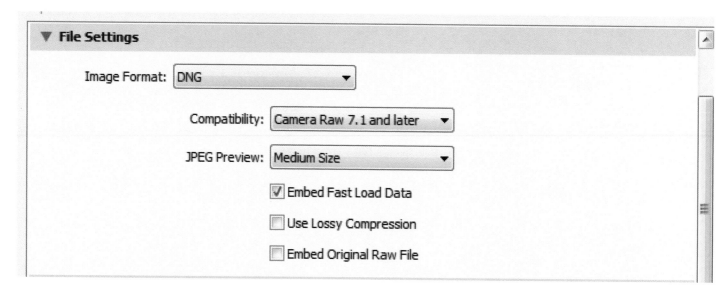

See where it says Compatibility? This plays a big role when you open the DNG file in an external program like Photoshop or Aperture. Check Online to figure out which version of Camera Raw you will need to make the DNG compatible with in order to open it without any problems in your other programs.

JPG Previews are embedded within the DNG file so that it will be able to load quickly. How big do you want them to be? Have a large monitor for your computer or a small one on a laptop?

Embed Fast Load Data is a setting I would not recommend changing because it will save you lots of time down the road when loading DNG files into other programs.

If you want to have a smaller file size you can put a check mark in the box for Use Lossy Compression. I wouldn't recommend doing this though because you should keep the DNG file as high quality as possible so you don't lose any data in the highlights and deep shadows. With lossy compression it is possible to lose some of the detail in these areas.

If you also want to include a copy of the original raw file that came from your camera go ahead and click the last box here. It will make your file MUCH bigger than a normal DNG though because it actually contains two raw files in it - the DNG and the native RAW format from your camera.

ORIGINAL FORMAT

If you select this option then Lightroom will simply make a copy of your original file and export it out to the destination folder.

IMAGE SIZING

Are you planning on making a canvas print from the file or just want to send it to your mother? I'm sure you already know what image size is already, so I'm just going to go straight to the settings here.

RESIZE TO FIT

First of all, if you want to resize the image you need to put a check mark in this box. If you don't then it will not let you click anything in here.

See where it says W and H? That is where you need to enter some numbers. Usually you will keep the default of Pixels, but if for some reason you want to resize the image to a specific number of centimeters you can select that option from the dropdown menu to the right of W and H.

DPI

In the screenshot above I have entered 72 into the box where it says resolution. Most people will want to use pixels per inch since that is fairly standard across the industry, but if you need to you can select pixels per cm from that dropdown menu. Whatever you enter in this box will determine how big the picture is when it gets printed.

72 pixels per inch is the standard resolution setting for anything on the web and 300 is a very common setting if you are printing images on high quality photo paper. For canvas prints, put 150 here.

RESIZING OPTIONS

Width and Height is Lightroom's way of saying 'longest dimension on either side.' For example, in my screenshot I have the width and height both set to 1500 and Width and Height. What this means is that landscape images will be 1500 pixels wide, but not that tall. Portrait orientation shots will be 1500 pixels tall, but not that wide. Basically, the longest dimension that a picture will have is going to be 1500.

If you select dimensions from the dropdown menu, Lightroom will stretch parts of your image to make it match those exact dimensions.

Long edge will make it so that the longest edge is going to be whatever number of pixels you have set and short edge will make it so that the shortest edge in the photo is whatever you have set.

Megapixels will just make the picture being exported the exact amount of megapixels that you write into the box if you select this.

To clear up any confusion here, lets take an example of a picture which is 6000x4000 pixels and we want to make it smaller.

Width and Height set to 1500 each will make this picture 1500x1000 pixels.

Dimensions set to 1500 and 1500 will make the picture 1500x1500 and it will look horrible.

Long edge set to 1500 would make it 1500x1000

Short edge set to 1500 would make it 1500x2250

Megapixels set to 6.0 would make the image 3000x2000

I hope that this makes some sense. If you stick to Width and Height as the primary setting it will be much easier.

ENLARGING

Normally I would not recommend upsizing your picture unless it is by a very very small amount. However, if for any reason you want to upsize the picture upon export and make it bigger than the original is you should make sure the check box that says Don't Enlarge is empty. If you want to make sure that Lightroom will not make the picture bigger than the original, put a check mark here.

OUTPUT SHARPENING

Not too many options here. If you want to sharpen your pictures put a check mark in the box and then select one of the three choices from the dropdown menu to the right. Your choices are Screen, Glossy Paper and Matte Paper. For websites use screen and for those different kinds of paper use those settings.

To the right of that is another dropdown menu that has three different amounts of sharpening that you can apply to the picture. Low, Standard and High are the choices and If you absolutely must do sharpening, I'd recommend using either the Low or Standard settings. Too much sharpening can make things look really funky.

METADATA

If you have made metadata changes to your picture or have added things like keywords and locations, pay attention to which option you select from here.

COPYRIGHT ONLY

Exactly as it sounds like. This will include only your copyright information (from the copyright section in the IPTC metadata) and nothing else.

COPYRIGHT AND CONTACT INFO ONLY

Also exactly what it sounds like. No special Lightroom lingo here. Your copyright and contact information from the IPTC metadata will be included and everything else will not be.

ALL EXCEPT CAMERA AND CAMERA RAW INFO

Since I am a bit more protective about my pictures, I like to not include the camera and camera raw information in my images when they get exported. What this means is that if someone downloads a picture from my website they will not be able to see what camera I used or the EXIF data.

With the All Except Camera & Camera Raw Info setting selected, your copyright information, keywords, contact information, etc. will all be included in the file's data.

ALL METADATA

This will include absolutely everything about your picture. The EXIF data including your camera, lens, exposure information and all that jazz. Any metadata you added for copyright, descriptions, titles, contact, etc. will also be included.

REMOVE LOCATION INFO

If you manually added a location to your image in the Map module or if your camera has Geo-coding enabled and automatically tags

images with locations, you can choose to not include this with the file when it is exported. Some people like to include it just because it is cool to see where pictures were taken and others like to not include it because of privacy concerns. Put a check mark in the box to get rid of the location data on the new file being created on export and keep the box clear to include it.

WRITE KEYWORDS AS LIGHTROOM HIERARCHY

If you do stock photography and do your own keywording pay attention to this one. Lightroom keywording hierarchy had to do with keyword tags and the level that each keyword is placed at. For example if you tagged something with San Francisco and had Lightroom set up to automatically add California to the keywords for that file, San Francisco would be placed at a higher level than California in the hierarchy. Some stock sites pay attention to the hierarchy of keywords and others do not. If they do pay attention to it, then check this box. If not, don't worry about it.

WATERMARKING

Do you want to watermark your pictures?

As you can see in my screenshot I have already created a few different watermarks and saved them. By default Lightroom will only have the 'Sample copyright Watermark' and nothing else, so if you want to include one you should click on Edit Watermarks and follow through the process below in order to create one for your pictures.

If you don't care about watermarking images then just ignore this and move on.

CREATING A WATERMARK

See where it says Edit Watermark in that dropdown menu? Click on that. You should see this screen come up...

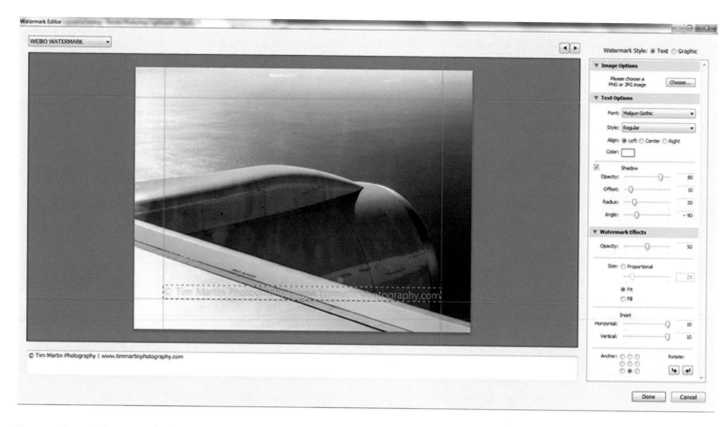

Lots and lots of things to check out on this screen. The first thing to consider though is if you already have a logo for your company or for yourself. If you do, then go ahead and click on Choose in the image options tab at the top right side of the screen. Select your JPG or PNG image there and move on to the other settings.

Don't have a logo or image file you want to use? No problem! See that big white box at the bottom? Write down whatever you want in there to be used as your watermark. In my example I've written the copyright symbol, my name and my website.

Going back to the right side of the screen, you can select any kind of font that you want which Lightroom has. There are quite a few options in here so it should be easy to find one you like. Same thing with the style - you have the normal choices of bold, italic, bold italic and regular.

Want the text to have a drop shadow on it? Many people use this if they are only showing a text watermark because it will appear less harsh than without a shadow, but it is entirely up to personal preference. Play around with these options and slider bars until you find something that you like.

Watermark effects is the tab where you can control how intense your watermark will be and the it's position within your picture.

Opacity means the same thing here that it means in Photoshop and other editing programs. A higher number will make it more visible and a lower number will make it less visible.

Proportional size means that the watermark will be adjusted to fit within any size of image no matter how big or small. If you use this option, Slide the bar to the right to make it bigger (it will be bigger than your picture if you go too far this way) and to the left to make it smaller.

Fit is usually a good choice for a watermark as well because Lightroom will scale it up and down to fit on whatever image you are applying it to.

See where it says Inset and has two slider bars for horizontal and vertical? These will change the location of your watermark from the anchor position (which you can select from the grid of nine dots at the bottom). Play around with these two sliders to move the watermark up and down (vertical) and give it more or less space from the sides of the image (horizontal).

Lastly, do you see those curvy arrows at the bottom right? These can rotate the watermark around, so if you want it to be on it's side instead of like how it is in the screenshot, click on one of these to rotate it by 90 degrees in either direction.

Once you are happy with how your watermark looks just go to the top left corner of your screen now and click on the dropdown menu. Select the save option and give your watermark a name!

POST PROCESSING

The last option for stuff when exporting images! Almost done...

After Lightroom is finished exporting your pictures, do you want to open them in Photoshop or another program? If you want to see them inside of the folder they were exported to, select Show in Explorer (Show in finder on Mac). If nothing, select Do Nothing.

For exports you want to open in Photoshop use that option and it will open each image in a different tab in Photoshop. For other applications you will need to select that application from a list after clicking on that option.

EXPORT PRESETS

Lightroom already has some presets made for exporting images and you can add your own too if you want. Take a look at the left side of the Export box. Do you see where it says Lightroom Presets and User Presets? Expand these tabs.

Take a look at each of the different presets that Lightroom already has and see if one of these matches the settings you need. If so, great! Click on it and export your files! If you can't find something in here you can use, then you can create your own. Just set all of the settings how you want and then click on Add at the bottom left of the Export box and write out a name for your export preset. It will be saved and you can use it anytime in the future after that!

Once you are completely finished with getting all of your settings right click on the button at the bottom right that says Export and Lightroom will start doing its thing.

EXPORT AS A CATALOG

:Lets say for the sake of argument that you have a big load of pictures that you want to share with a client or your friends and family who also use Lightroom. One of the easiest ways to do this is to export a batch of images as a catalog! When you do this, you will have a complete package deal to send off that will include your image files, their develop and metadata settings, ratings, colors, flags and everything else that you have done to the image.

To export a batch of images as a catalog just go to File and select Export as Catalog from the options. It should be about half of the way down the menu...

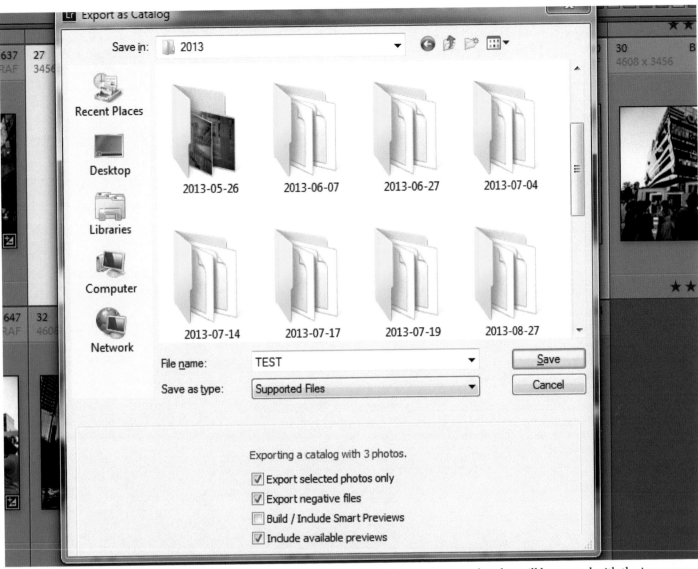

When Lightroom pops up with the screen you see above, just type a name for your new catalog that will be created with the images you selected. If you want to put it into a different folder or somewhere on your desktop, go for it!

See those check boxes below where you type the new catalog's name? Pay attention to these because your client or friend may need some of these things to be done before they open it up.

EXPORT SELECTED PHOTOS ONLY

Just what it sounds like. If you are exporting an entire collection or folder and have every image selected to export as a collection this box will not appear. If you have specific images selected though, it will show up here.

EXPORT NEGATIVE FILES

Do you want to make copies of the original pictures to go along with the new catalog? If you do, make sure you have a check mark in this box. What it will do is make a folder for the new pictures within the folder for your new catalog and link all of the pictures to the new catalog.

This may sound a little bit confusing at first, but it will make perfect sense when you see it happening.

If you do not want to include copies of the original files in the new catalog, remove the check mark from this box. I would not recommend doing this unless you are creating the catalog with the sole purpose of using it on your computer and not on someone else's computer.

BUILD/INCLUDE SMART PREVIEWS

If you already created smart previews for your images, Lightroom can include them with the new catalog and if you have not created them yet, Lightroom can build them during the export so that you can access the catalog and do develop adjustments without having the source files at the same time.

INCLUDE AVAILABLE PREVIEWS

Lightroom saves previews for whatever amount of time you specified when setting up your preferences and catalog settings. If there are previews still in the catalog you are viewing your pictures in, do you want them to be included in the new catalog as well?

This is a good thing to do if you are passing the new catalog off to someone else because it will ultimately save time on their end when loading the Lightroom catalog and viewing the images in it for the first time. If you don't plan on doing that, go ahead and remove the check box here.

TIP: Not including previews will make the new catalog a bit smaller and it will export faster, but if you do not include them and do not have the negative images included, the new catalog will have very limited usage because you won't be able to see anything!

EDITING A VIDEO

This can only be done by using the Quick Develop tab in the panel on the right side of Lightroom. To edit a video, just open it up in Loupe View (the big picture mode) and open the Quick Develop tab.

There are some pretty big limitations to what you can do to video files in Lightroom, but at least you can do some things! Basic adjustments for temperature, color, exposure, contrast, whites and shadows (but not highlights and blacks) and vibrance.

You can see in the above screenshot the sections which are grayed out in the Quick Develop tab. Those ones you cannot use, but the others you can.

TIP: If you have already done a lot of adjustments to basic tools in a preset you can select that preset from the list at the top of the Quick Develop tab and it will apply all of the settings that it can apply. While it will not add clarity or anything graduated filters, it will make all of the basic changes and might be a quicker way to develop your video before exporting it!

TETHERED CAPTURE

Tethered shooting is an incredibly useful tool to use when you are in a studio setup and is one of the features that makes Lightroom stand out among other programs. For those who are not entirely sure what tethered shooting is, it is when you plug your camera into the computer and shoot live. When you take a picture, it is immediately transferred to Lightroom and added to your catalog.

OPENING TETHERED CAPTURE

To open up this mode, just go to File, then Tethered Capture and click on Start Tethered Capture.

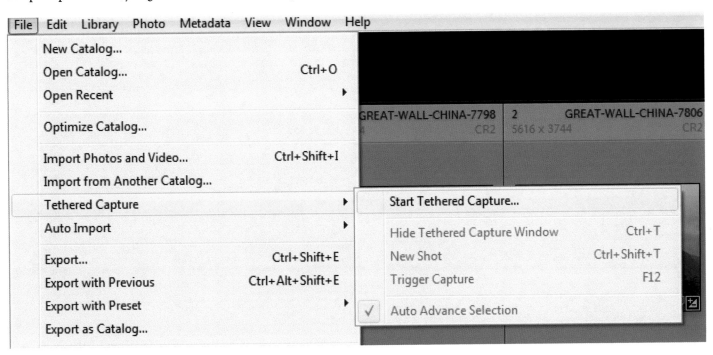

Once you click on that, you need to start filling in your settings.

TETHERED CAPTURE SETTINGS

Similar to when you import images, you will need to create a naming scheme for your images, select the destination folder and all of that jazz.

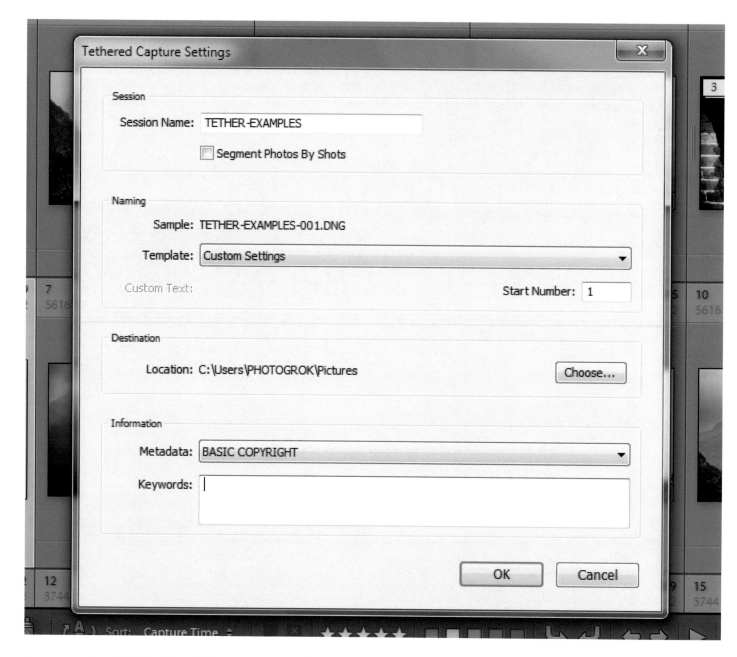

By now you should be familiar with these settings, so I'll not waste your time explaining all of that stuff again.

Right, so, click OK and lets get down to the whole business of tethered shooting!

SHOOTING

Does your screen have something that looks like this now? Great!

Lets make sure that your camera is turned on and is attached to your computer with a USB cable. If it isn't, do that now. Otherwise, tethered capture will not work.

As you can see in the screenshot above, the tethered capture thing will display your camera information on it. The camera's make and model, shutter speed, aperture and white balance.

Where it says Develop Settings (by default it will have None here) you can select any develop presets that you have made before or use any of the ones which are included with Lightroom. These develop settings will be applied to the pictures immediately and when you see the new images showing up on your screen, you will see them with these adjustments already applied.

The big gray circular button on the right side is another way to take a picture. So, if you using a tripod and have everything set up but don't want to touch the camera, you can click on this button and Lightroom will send the signal to take a picture via the USB cable.

Go ahead and start taking some pictures. Do you see how they start showing up on the screen?

Lightroom has an auto-advance feature built in, so every time a new picture finishes transferring through the USB cable it will show in Loupe View.

If you did work on an image while in tethered capture mode and want those adjustments to be applied to the next image that you take as well, select Same as Previous from the list of options (second from the top).

If you do not want Lightroom to auto advance to the new images, just go to the File menu and into Tethered Capture then remove the check mark from the item about auto advancing.

To exit tethered capture mode you just need to click on the X in the tethered capture bar or go through the file menu again and end the session.

Tethered capture is a very advanced use of Lightroom and there is a lot more than can be done with it if you choose to. A quick search through the Adobe help website will give you plenty more information for things like overlaying an image into a layout. If you're interested in more information, check out their website or shoot me an email (contact information is at the end of the book).

OTHER USEFUL STUFF

Lightroom has a lot of somewhat hidden functions and features that can be very useful if you know about them. Here are some of the ones that I find myself and other photographers using quite often.

RENAMING FILES

Instead of dragging your files into Bridge or another program that you are used to using to rename files, why not do it in Lightroom? Before renaming files you should select all of the ones you want to chance and then either hit the F2 key on your keyboard or go to the Library menu at the top of your screen and selecting Rename Photos from the list.

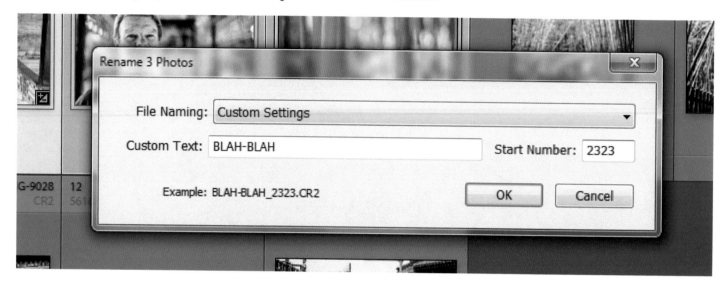

It will bring up this box here. You can create a custom setting in the same way that you did when importing and exporting images and select a starting number (if your naming structure includes a sequence number). After pressing the OK button Lightroom will go through and rename your files! Super quick and easy compared to Bridge since you can rename images which are contained inside of multiple folders without having to do it one folder at a time.

SYNCHRONIZE FOLDERS

If you, like most people, are not the most meticulous and add new files to a folder or forget to do it within Lightroom, there is a really useful feature that allows you to synchronize folders and make things match up again!

To do this, go to Library and select Synchronize Folder. It will bring up a dialog box that looks like this:

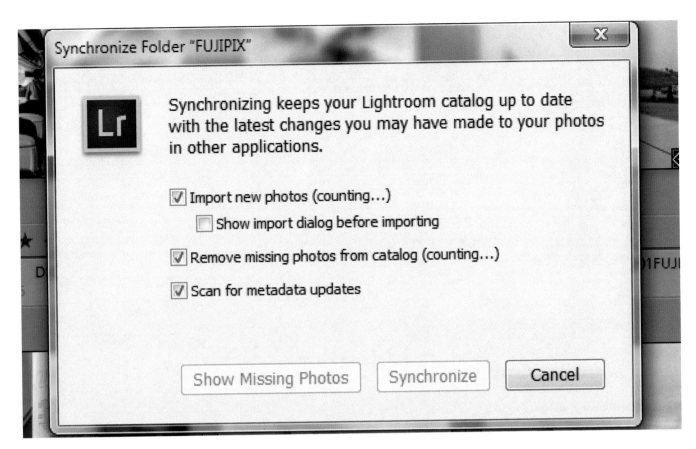

Just let it sit for a while. Do you see where it says (counting...) next to some of those items? Once it is finished counting, Lightroom will display a number there. If you don't have any new files, it will put a 0 there and if you have new images in the folder that have not been added to Lightroom yet, it will have a number there and you have the option to import them.

When importing images from a synchronized folder you have two options; with and without the import dialog. If you want to rename the files or add metadata and/or presets to it, then put a check mark in the box below that says Show import dialog before importing and it will do exactly that. If you want to simply import them without adding anything to the files, just check the top box for Import new photos and leave the other one alone.

Missing images can be removed from the catalog this way as well. The check box for Remove missing images from catalog is where you can decide about this. Keep in mind though, if you synchronize a folder that is on an external hard drive that is not currently plugged in, Lightroom will count all of those images as missing and will remove them from the catalog if you check this box.

To view any missing images just click the button for Show Missing Photos at the bottom of the dialog box. It will show you all of the missing pictures and you can decide what to do about those later by either finding them or removing them from the catalog or leaving everything how it was and making no changes at all.

Scanning for metadata updates will look at each file in the folder and check to see if any metadata changes have been made in other programs. If, for example, you did a batch keywording session in Bridge and want those new keywords to show up in Lightroom, this is how you would go about it!

To proceed with synchronizing the folder, just click the Synchronize button and Lightroom will go through the motions and do all of the things you have told it to do.

OPTIMIZE CATALOG

Optimizing your catalog has the potential to make things run a lot faster and smoother.

To do this, go to File and select Optimize Catalog.

Go ahead and click on Optimize. Depending on the size of your catalog and how many pictures/develop adjustments/metadata additions you have made it can take anywhere from a few minutes to eternity and you will not be able to use Lightroom at all during the whole optimization process. So, just grab a cup of coffee and sit back or take a break and do something else for a while. Unfortunately, Lightroom doesn't give any kind of progress bar with an amount of time on it, so there isn't any accurate way to judge how long the optimization will take.

When it is all finished Lightroom will tell you that your catalog has been optimized. Does it run any faster now? If so, thats great!

RENDER 1:1 PREVIEWS

If you did not render 1:1 previews when importing images to your catalog and found that Lightroom is taking a long time to fully load images while editing through them, you have the option to render full-size previews all at once so that you can seamlessly view big beautiful images without waiting for them to load one by one!

Be warned before you do this that it can take a long time if you are rendering 1:1 previews for a large number of images or if your computer is naturally a bit slow because of hardware specs.

Select all of the pictures you want to render full size previews for. Make sure they are selected, then go to Library and select Previews from the menu, then select 1:1 previews. It will scan through the images you have already selected and figure out if any of them already have previews, then will go ahead and start building them. To check the progress of this, go to the top left of your screen in Lightroom to check the progress bar.

When Lightroom is finished with this process the progress bar will disappear and you can go about your business as usual.

RENDERING AND DISCARDING OTHER PREVIEWS

Also in that menu section for Previews (Library -> Previews in the menu) you have a few other options to play around with. If you want to build smart previews, standard previews or discard any type of previews you can do that here.

It is really simple to do this. Just make your selection of pictures that you want to create or remove previews for and then go to this menu and select your choice from the options.

Discarding previews is one of the things I do quite often to make my catalog file a bit smaller. A smaller catalog runs faster than an enormous one, so when I am 100% finished with a bunch of images I will discard the previews for everything except the best images just so I can keep the catalog at a reasonable size.

FULLSCREEN MODE

Just like most other programs, Lightroom also has a fullscreen mode. It is really easy to use too! To enter fullscreen mode, just hit the F key on your keyboard and Lightroom will display your selected image on the screen really really big and beautifully. To exit fullscreen mode, hit F again or hit the Escape key.

TOOLBAR VIEW MODES

Do you remember the toolbar? Press the T key on your keyboard to show and hide it. Got it? Great! Now take a look at the left side of the toolbar.

The different colored arrows in the screenshot above are pointing to the icons you can use for selecting different view modes. The Red arrow pointing towards the thing that looks like a grid is for Grid View. The Yellow arrow is for Loupe View, Green arrow for Compare and Cyan arrow for Survey.

SPRAY PAINT CAN

Another cool thing in the toolbar is the spray paint can. Do you see it here?

Click on this thing.

Now, click on the thing that says Keywords. It will pop up the menu that you see in the screenshot above.

So how does the paint can work? Basically, you choose whatever you want it to do from this menu and enter the applicable thing in the grayed out box to the right. If it is keywords, then select keywords and enter the ones you want to add images to the right. Then, using the paint can, just click on all of the pictures you want to apply those keywords to. It is really simple and easy to use.

If you have more than one image selected, the paint can will 'spray' both of them at the same time. It is a very quick and efficient way to add keywords to an image!

You can use it to apply keywords, labels, flags, ratings, metadata, settings, rotation orientations and even to add it to a target collection.

SORTING OPTIONS

In the Library Module, how do you want to order your pictures? In a collection it is a bit irrelevant because you can create a custom order, but in everything else Lightroom is sorting your image in a specific way - usually by the order in which they were added or the date taken.

Click on the words to the right of where it says Sort and you will get these options.

From there it should be pretty much straightforward. If you sort by capture time, it will arrange them with the earliest on top and the latest on bottom. If you sort by star ratings, it will show the 5-star selects on the top and the 1-star selects on the bottom and so forth.

Do you see that icon to the left of where it says Sort? The one with an A and a Z and twisty arrows on it? If you click on that it will reverse the sorting order. For example, if you are sorting by added order, then click on that reverse button, the most recently added images will be at the top and the ones you added previously will show at the very bottom.

Cool, right?

THUMBNAIL SIZE

The last thing that you can do with the toolbar is adjust the size of the thumbnails you see in Grid View. Look for the slider bar on the far right side of the toolbar.

By dragging the slider to the right it makes the thumbnails bigger and left is smaller.

An easier way to do this though, in my opinion, is by using the + and - keys on your keyboard to make thumbnails bigger and smaller respectively.

TOOLBAR EXTRAS

Look at the far right side of the toolbar. Do yous see the little triangle that points down? Click on that and you will see a few other options to add to the toolbar.

Below is a screenshot of all of the different options on the toolbar at the same time.

PROGRESS BAR

Ever wonder how far along that import or export is? Or whatever else you happen to be doing in bulk. Lightroom has a progress bar tucked away at the top left of the screen when your header is expanded. To check it out, go ahead and

Lets say that you have more than one task which is being processed right now. How do you go about seeing both of them and how far along each one is?

Lightroom will display all of the ongoing tasks up here in a series of bars, like in the screenshot above where you can see two operations in progress.

If you want to cancel a task, simply click on the progress bar that applies to the one you want to cancel and then click on the X which will appear on the right side of the bar. You won't be able to miss it when you try it, and Lightroom will take a few seconds to completely cancel the task and remove the progress bar from up here.

REFINE PHOTOS

Refining photos is another way to speed up your workflow when making selects and trying to narrow down the number of good images. It only works with flags though, so be sure that you are using flags as a method of marking your images if you want to use this feature.

To use it, go to the Library menu and select Refine Photos or hit Control+Alt+R on your keyboard.

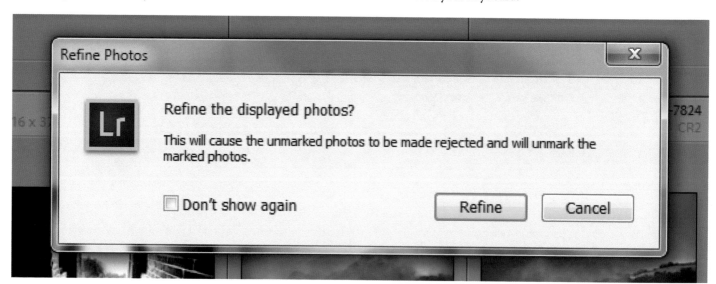

What it will do is take all of your pictures which have no flag and mark them as rejected, then take all of the photos which had flags and now make them unflagged. Try to think of it as knocking the flag level down by one each time.

Also, when using this feature, Lightroom will only display unflagged images after the refining is finished. This helps to keep your screen nice and clean and hide away the junk so that you can run through the images another time adding flags in order to refine them more.

STACKING

Do you have OCD or just like to be very very organized? Stacking is a great feature in Lightroom that can clear up a lot of clutter in Grid View. Stacking is what it sounds like - stacking images on top of each other.

A lot of people do this for groups of similars so that they can see their truly different shot setups all on a single screen and then expand the stacks when they want to view the contents of a shot scenario.

To stack a group of photos together, go to Grid view and select the pictures that you want to stack. Right+Click on any of the pictures and click on Stacking, then Group Into Stack.

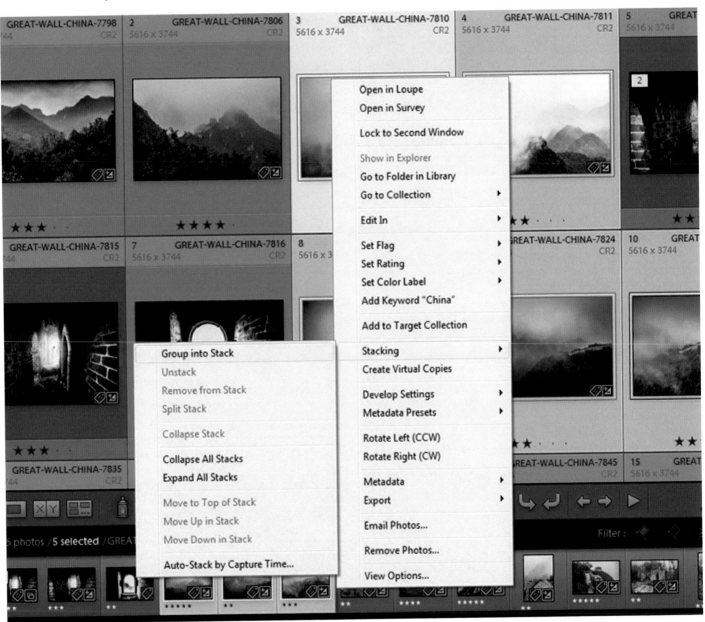

Once you do that, you should see just one picture instead of all of the ones you had selected before. In the top left corner of the thumbnail of that image will be an icon that looks like sheets of paper stacked together with a number in the middle of it. That number denotes the number of images included in the stack.

To view all of the images inside the stack, just click on the number in the icon or right click, go to Stacking and select Expand Stack.

Once it has been expanded, you will be able to see all of the images inside of it, similar to how they were before. However, this time the cells for the images included in the stack will have a darker shade of gray compared to those which are not part of a stack.

You can expand and collapse all of the stacks in your library through the stacking menu, or just do it individually. It is a complete matter of personal preference, so you should choose whichever feels and looks best for you.

Also, if you have a group of images stacked together and want to add an image to the stack, all you need to do is click and drag that image on top of the stacked image and let go of your mouse. It will be added. Similarly, to remove an image from the stack all you need to do is click on it and drag it out of the stack and let go of the mouse.

You can re-order images within the stack in the same fashion by clicking and dragging into position. When you do that, you should see a black bar appear between the cells of two images - this black line indicates where the picture will be placed when you let go of the mouse.

FIND

When you use Safari or Chrome or any of your other web browsers, do you ever use the find feature to find a specific word on the page? Lightroom can do this as well!

Just hit Control+F (Command+F for Mac) and Lightroom will bring the Library Filter up with a blank box for you to enter text for.

As you can see in the screenshot, the settings are for any searchable field and contains all. This is generally fine, unless you are searching for something a bit more in-depth. Just enter the word you want to find and if it is part of the filename, metadata, keyword or anything else, Lightroom will show it to you!

If you can't find what you are looking for, check to see if you have any filters applied for flags, ratings or colors. If you do, then remove those filters and try it again.

CONVERT FILES TO DNG

If you didn't convert your files to DNG format upon import, you can still do it after the fact. It is quite simple and easy. Just select all of the images you want to convert into DNG format

Go to Library and select Convert Photos to DNG.

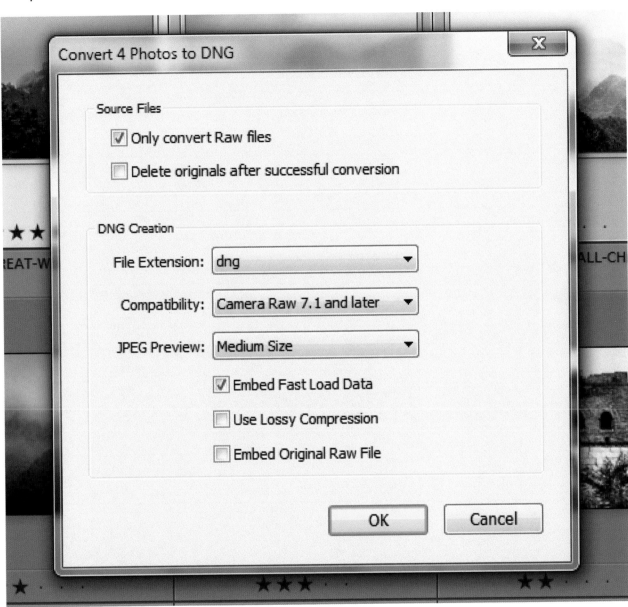

This box will pop up and you should set your settings here.

If you want to keep your original RAW files then the default is fine, but if you want to delete the original RAW files after finishing converting to DNG you should put a check mark in the second check mark box from the top of the dialog box.

VIRTUAL COPIES

Virtual copies are a cool thing that Lightroom is capable of creating. In essence they are just second copies of images without making a physical copy of the image. they can have different develop settings, different metadata settings, etc. They are treated as separate images which are stacked with the original image (although if you want to, you can unstack them from the original.

To create a virtual copy just right click on an image in Grid View and select Create Virtual Copy.

FIND ALL MISSING PHOTOS

Instead of searching through your folders to see which images are missing and which ones are not missing, you can easily find all of them by going to Library and selecting Find all Missing Photos.

When you do this, Lightroom will create a quick collection called Missing Images and stick it in the Catalog tab on the left panel. All of the pictures which are currently missing will be added to that collection. If you have a lot of pictures on a hard drive, then this may not be so useful, but if you move things around on your desktop a lot it can come in quite handy.

TROUBLESHOOTING LIBRARY MODULE PROBLEMS

Where are my pictures at?

Make sure you have selected the correct folder or collection from the panel on the left side of Lightroom. Once you can confirm that you are indeed looking in the correct place check to make sure you don't have any filters applied. These could be star ratings, flags, metadata filters or anything else.

Where are the panels at?

The panels on the left and right side of your screen can be hidden by pressing the Tab key. If you hit the tab key when both panels are showing, it will hide them and vice verse; hitting the Tab key when they are hidden will show them again.

Where did the filmstrip go to?

Remember the filmstrip? Its that thing on the bottom of your screen that looks like a filmstrip. There are two ways to make sure it is visible. One is by pressing Control+Shift+Tab at the same time (Command+Shift+Tab on a Mac) or by clicking on the little triangle in the center of the bottom of your screen. This will show it!

Where is the Library Filter at?

If you press the \ key on your keyboard it will show and hide the filter. There are no little arrows for this the Library filter, so make sure to remember this little shortcut. Another option is to hit Control+f (Command+f on Mac) to trigger the "find" feature. This will also bring up the library filter and you can just take it from there.

How do I switch View Modes?

Easy enough, you can do this in a few different ways. For me the easiest way is by using the shortcuts in Lightroom. To enter Loupe view and show only one big picture on the screen, just hit the E key. To go to grid, hit the G key on your keyboard. Other ways to do this would be by clicking on the little icons at the bottom left part of your screen. To go to Survey View just hit N and to enter Compare view just press C.

Lightroom can't find my files...

It is easy to move things around in Finder and Explorer without thinking of what it will do to Lightroom when you open it up again. If for any reason something was moved around on your computer, you will see something that says 'The folder could not be found' or something similar to that. Check out the screenshot below for some other ways to tell if the pictures and folders have been moved around.

Do you see the little ? symbol and the grayed out text on the folder in the tab on the left side? If a folder has that icon instead of the more normal looking ones, it means Lightroom cannot find it. The other red arrow in the screenshot is pointing to a ! symbol in the top right corner of a picture in Grid View. If a picture has that ! on it, it means that Lightroom cannot find the picture.

Don't worry though, not all is lost. Unless your kids decided to take a bath with your hard drives... in that case you might be out of luck. Anyways, to find and re-link a missing folder just Right+Click or Command+Click on the ? symbol and select Find Missing Folder. Explorer or Finder will pop up and you should navigate through the abyss of your computer to find where the folder has been moved to. You do not need to move it again, just locate the folder and press Select in the dialog box once you've found it. Lightroom will scan through all of the images in that folder and re-link them so that they are all in their correct place again!

What if you moved a big big big folder with lots of smaller folders inside of it? You don't need to re-link all of them. Just Right+Click on the question mark of one of them and select 'Show Parent Folder' and Lightroom will add the folder that the missing one was inside of before. Right+Click on that folder now and locate it. Everything contained inside of the big big folder will be scanned and re-linked.

To locate a missing image file, just click on the ! symbol at the top right corner of your image and select Locate. Find the picture again and click Select for Lightroom to re-link it. Again, you do not need to move the picture file back to it's original location.

Going a bit more into the missing images and missing folders, lets say that a picture or a folder has been renamed outside of Lightroom. How does it work then? It actually works in the exact same way, but you will have to press the enter key a few more times than before.

All of that being said, I should stress more that if you want to move folders around from their original locations, please try to do it inside of Lightroom. You can click and drag the folder inside of the Folders Tab in the left panel and drop it inside of another one there. By Right+Clicking you can also create new folders, show the folder above the one it currently has (parent folder) and much more.

When moving pictures and files inside of Lightroom, it will save you time since you won't need to get frustrated and worry about where the heck your pictures disappeared to, and there won't be any stress about finding and re-linking folders and images.

Which photo is the most selected?

Lightroom decided to be a pain in the butt by creating the ability to have selected and most selected files at the same time. Basically, if you are in Grid View or on the Filmstrip and have a number of images selected at the same time, all of them are selected and one of them is 'most selected.'

Do you see how one of the images in the screenshot has a brighter shade of gray in it's cell? That is the most selected one. All of the others which are selected will have the same, slightly less bright shade of gray in their cell.

Are there other ways to select views and tools?

Of course there are! If you like to use your mouse and clicking lots of things, then you can always use the menus at the top of your

screen. Everything in the Library module is going to be in there too, so if you take a look around the menus you will be able to find all of the same tools and functions.

What can I do to make Lightroom faster?

Lightroom can run really slow sometimes for a number of reasons. Here are some of the most common ones that I've run into before:

Too many programs running simultaneously

If you are running Lightroom, Photoshop, iTunes, Chrome, Premier Pro and a graphic intensive game all at the same time your computer may not be able to keep up with everything and will run slowly. This has more to do with your computer than any settings you can change in Lightroom.

Camera Raw Cache is full

This can become a problem if you keep 1:1 previews of all of your pictures and have a large amount of them. Passing through the Develop Module often. Try increasing the size of your previews cache by accessing the going to the Preferences box and then going to the File Handling tab. The cache setting is at the bottom. You can check out the size that you have set, then go to the folder (the file path is written right here in this section) and check out the size of that.

If the folder with your cache in it is full, you should click the button for Purge Cache (nerd lingo for deleting it and starting fresh with a clean slate). If it wasn't full, then this is not what is causing Lightroom to slow down.

Cache Location is not optimal

The best place to store your cache is on an internal drive, preferably an SSD. The faster that your internal drive is, the faster Lightroom will be able to access your cache and pull up data from it. If you do not have an SSD, but your computer has USB 3.0, that is another option providing you have a USB 3.0 drive that is faster than the internal hard drive on your laptop or desktop.

Your video cache is full

If you take videos and preview them in Lightroom, the video cache can fill up insanely fast. The video cache settings are also in Preferences in the file Handling tab. Try increasing the size of your video cache or purging the cache and see if that speeds things up at all.

Are you importing/exporting?

One thing that I've noticed will slow Lightroom down a lot is importing or exporting images while working on other pictures at the same time. Importing and exporting can be processor intensive if you are applying develop and metadata changes to images or converting them to DNG or other formats at the same time. Wait until your import/export is done and see if Lightroom has gotten back to its normal speed yet!

Not enough RAM or processing power

If you are using an older computer with less RAM or a processor that is slower than the most modern ones, Lightroom will naturally run slower because it has been optimized for fast 64-bit processors. I'm afraid there isn't much you can do to help it speed up here aside from upgrading your computer's components and/or running only Lightroom and no other programs at the same time.

XMP files

Do you remember when we went through the settings menus and there was an option for XMP files? If you enabled that, then every time you add a keyword to an image or make a change to it, the XMP file is rebuilt. For batch processing of images this can take excruciating amounts of time if a lot of changes are being made. To speed Lightroom up, just disable writing changes to XMP files. To do this, go to the Catalog Settings and click on the Metadata tab. The check box at the bottom of the screen is where the XMP setting is at.

Be warned about doing this though, because any changes you make in Lightroom to a file will not be visible in other programs until you create an XMP file for it again.

Where is your catalog stored?

If you keep your catalog on your internal hard drive in a laptop or desktop it might run slower because the read/write speed of your hard drive cannot keep up with the massive amounts of data flowing through Lightroom. To speed things up, try putting your catalog (and most importantly, the previews file (the one which ends with .lrdata) on a USB3.0 drive or a Solid State Drive (SSD). This can help dramatically speed things up.

Are you constantly rendering previews for images?

If Lightroom is always giving you pixelated looking images that slowly become normal looking as they load, you might want to try rendering 1:1 previews for all of your pictures before trying to do a lot of work on them. Let your computer run overnight rendering previews and try it out again the next morning and see if that helped things become faster.

SHORTCUT KEYS

Here is a list of some very useful and time saving shortcuts that you can use in the Library Module of Lightroom 5!

PANEL SHORTCUTS

Show/Hide panels on left and right side	TAB
Show/Hide all panels	SHIFT+TAB
Show/Hide Toolbar	T
Show/Hide Module Picker (thing at the top)	F5
Show/Hide Filmstrip	F6
Show/Hide Left Panel	F7
Show/Hide Right Panel	F8

MODULE SHORTCUTS

Go to Library Module	CONTROL+ALT+1
Go to Develop Module	CONTROL+ALT+2
Go to Slideshow Module	CONTROL+ALT+3
Go to Print Module	CONTROL+ALT+4
Go to Web Module	CONTROL+ALT+5

LIBRARY VIEW MODES SHORTCUTS

Loupe View	E
Grid View	G
Compare View	C
Survey View	N
Lights Out Modes (It cycles through them)	L
Fullscreen Mode	F
Info Overlay (cycles through them)	I

SECOND WINDOW SHORTCUTS

Open Second Window	F11 (COMMAND+F11 on Mac)
Grid View	SHIFT+G
Loupe View	SHIFT+E
Compare View	SHIFT+C
Survey View	SHIFT+N

RATING AND FILTER SHORTCUTS

Stars (1-5)	1-5
Remove Stars	0
Flagged	P
Unflag	U
Reject	X
Red Label	6
Yellow Label	7
Green Label	8
Blue Label	9

OTHER SHORTCUTS

Show/Hide Tethered Capture Bar	CONTROL+T (COMMAND+T on Mac)
Create Virtual Copy	CONTROL+' (Command+' on Mac)
Rename Photos	F2

Edit in Photoshop	CONTROL+E (COMMAND+E on Mac)
Export Photos	CONTROL+SHIFT+E (COMMAND+SHIFT+E on Mac)
Rotate Clockwise	CONTROL+] (COMMAND+] on Mac)
Rotate Counterclockwise	CONTROL+[(COMMAND+[on Mac)
Increase Thumbnail Size	+
Decrease Thumbnail Size	-
Show/Hide Filter Bar	\
Add to Target Collection	B

There are many more shortcuts out there for Lightroom and functions and tools in the Library Module and if you are really interested in them, I suggest going to the Adobe help website and checking out their gigantic list!

CLOSING NOTES

Thank you for taking the time to read through the Library Module guide for Adobe Photoshop Lightroom 5. If you have any question or comments please email me at tim@timmartinphotography.com and I will try to get back to you as soon as possible. I will be updating sections of this book and the other books in my Lightroom 5 series when new questions arise and any feedback from you will be help me make this guide work even better for you!

All of the images used in the book were taken by me and have been retouched purely in Lightroom 5 with no exceptions.

If you found this guide to the Library Module to be helpful, please take a look at the other two books in the series: Develop Module and Map, Book, Slideshow, Print and Web.

CONTENTS